MODERN
TAPESTRY
CROCHET

MODERN
TAPESTRY
CROCHET

Techniques > Projects > Adventure

ALESSANDRA HAYDEN

>>>>>>>>>>

Interweave

fw

www.fwcommunity.com

21 20 19 18 17 5 4 3 2 1

**DISTRIBUTED IN CANADA
BY FRASER DIRECT**

100 Armstrong Avenue

Georgetown, ON, Canada L7G 5S4

Tel: (905) 877-4411

**DISTRIBUTED IN THE
U.K. & EUROPE BY F&W MEDIA
INTERNATIONAL**

F&W Media International Ltd.

Pynes Hill Court | Pynes Hill

Rydon Lane | Exeter

EX2 5SP | United Kingdom

Tel: (+44) 1626-323236 (phone)

E-mail: enquiries@fwmedia.com

SRN: 17CR01

ISBN-13: 978-1-63250-564-4

EDITOR

Maya Elson

TECHNICAL EDITOR

Daniela Nii

COVER & INTERIOR DESIGNER

Pamela Norman

ILLUSTRATORS

Daniela Nii, Kathie Kelleher

PHOTOGRAPHER

Harper Point Photography

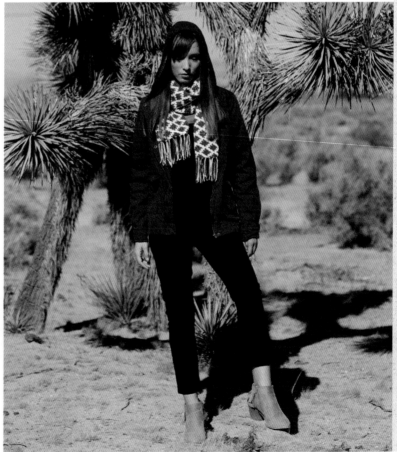

CONTENTS

>>>>>>>>>>>>>>>>>

INTRODUCTION

>>>>>>>>>>>>>>>>>

I first learned to crochet when I was eight years old. My mother had recently passed away, and I was spending a lot of time with my grandma, who was an amazing crafter. Her ability to make something out of seemingly nothing captivated me. She taught me to crochet as a means to keep me busy, and despite the fact she started me on a tiny steel hook with frustratingly slippery silk thread, I stuck with it. My first project was a cozy for a wooden hanger, and before long, I had a closet full of colorful hangers.

Over the years, crochet stayed with me. In high school, I continued crocheting as a hobby and even stitched my own clothes. In 2008, after suffering a personal loss, crochet became my therapy and, eventually, my career. Counting stitches kept my mind busy, and using bright, colorful yarn helped me feel happy. I started selling my projects and receiving inquiries about patterns, and the rest is history!

My fascination with tapestry crochet stemmed from a desire to incorporate color and pattern into crochet. I've always been drawn to bright, vibrant colors and greatly admire the colors and patterns associated with Fair Isle knitting. Though I am comfortable with the basics of knitting, I never hit the same rhythm with it that I have with crochet. Tapestry crochet allows me to create intricately colored pieces reminiscent of Fair Isle designs, while still working with a single hook. The technique I use is relatively simple, and once you try it, I'm confident you'll be crocheting beautiful colorwork in no time!

Happy Crocheting!

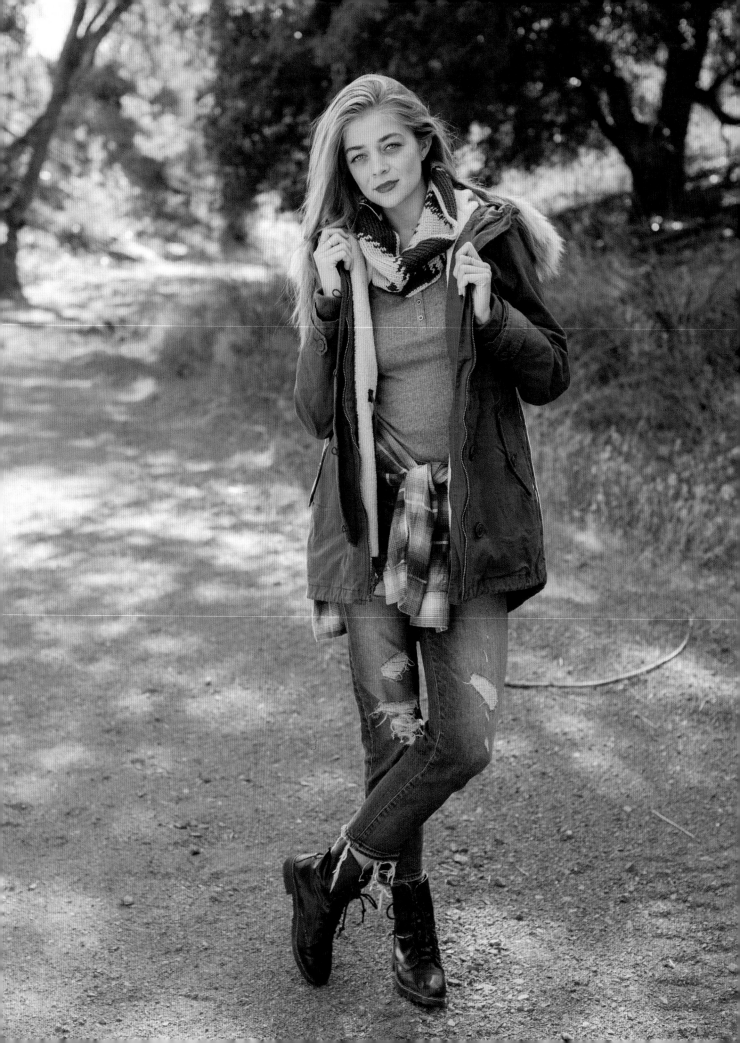

MATERIALS & TOOLS

>>>>>>>>>>>>>>>>>>>>>

THE BEST THING ABOUT TAPESTRY CROCHET IS THAT
IT REALLY DOESN'T REQUIRE ANY SPECIAL TOOLS, ALL
YOU NEED IS A CROCHET HOOK AND SOME YARN,
AND YOU'RE READY TO GO! I HAVE DEVELOPED SOME
PREFERENCES OVER THE YEARS, WHICH I'LL COVER IN THE
FOLLOWING PAGES, BUT FEEL FREE TO EXPERIMENT
TO DETERMINE WHAT WORKS BEST FOR YOU.

YARN

Any yarn can be used for tapestry crochet. I prefer to work with natural fibers because they are more easily blocked. I also tend to stick with medium-weight yarns (DK, sport, worsted, and aran) when working tapestry crochet. Since this type of crochet requires you to always crochet over at least one thread of yarn, I find bulkier yarns tend to result in a fabric that is too thick and stiff. And if the yarn is too fine, the design doesn't show as well as I like.

In the end, it's important to choose your yarn depending on the item you are making. Lighter-weight yarns are fabulous for crocheting delicate items, and medium weight and heavier are great for bags and winter accessories. Just remember: Natural fibers can be blocked and shaped better than acrylics.

TOOLS

As I've mentioned, you don't need any fancy tools to create beautiful tapestry crochet. As long as you have some good basics, you will be all set.

Crochet hook. You'll need your favorite crochet hook in the appropriate size to get gauge for the pattern in question **(Figure 1)**.

Stitch markers. These are good to have on hand for marking rounds and pattern repeats **(Figure 2)**.

Scissors. Any basic snips will do for trimming loose ends **(Figure 3)**.

Tapestry needle. This is essential for weaving in loose ends.

Needle & thread. The bag projects in this book do require some sewing to attach the straps and handles or a zipper. I prefer handsewing all of these elements, but if you prefer using a sewing machine, please do **(Figure 4)**!

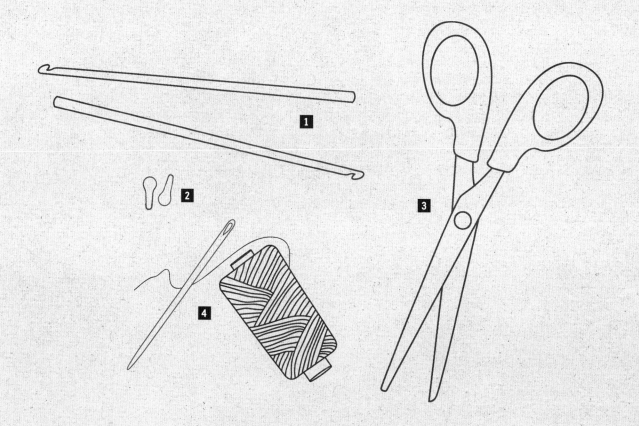

illustrations by Netkoff

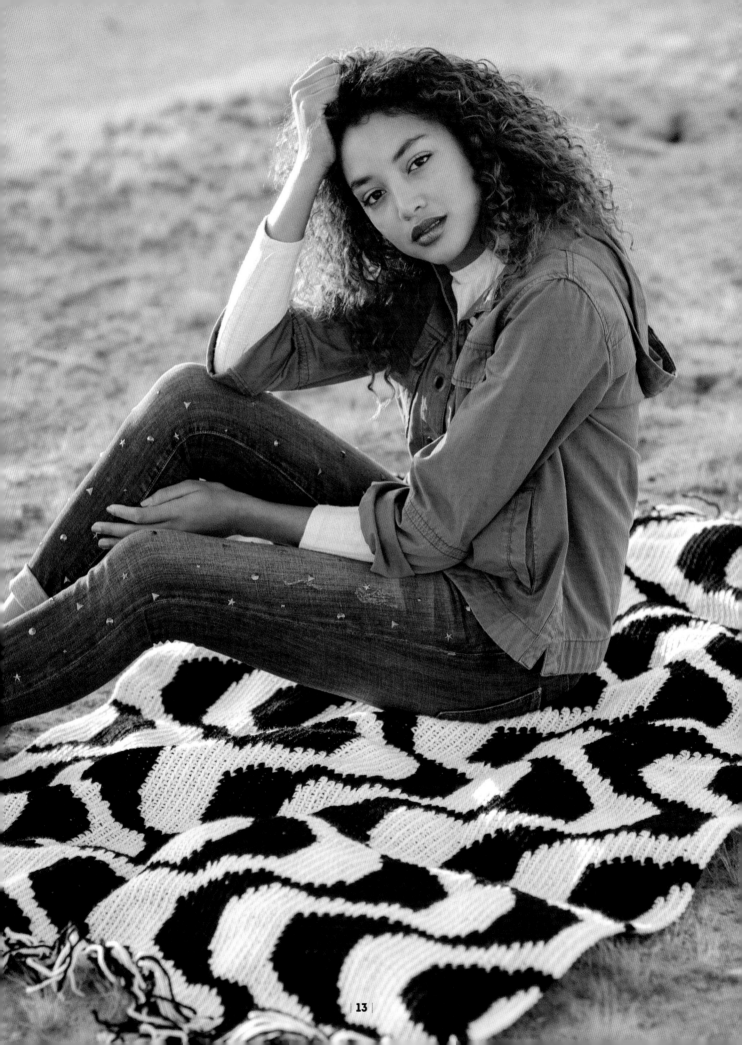

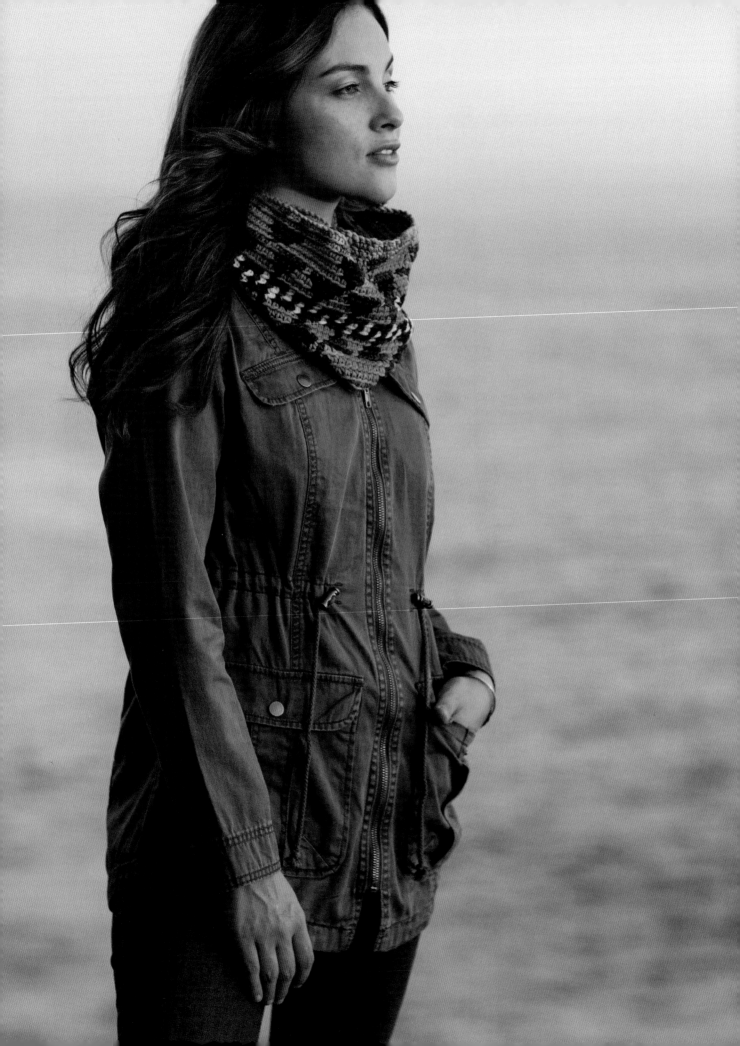

TECHNIQUES

>>>>>>>>>>>>>>>>>

TAPESTRY CROCHET IS REALLY A VERY SIMPLE
CONCEPT, AND WITH A FEW GOOD PRACTICES
UNDER YOUR BELT, YOU'LL SUCCESSFULLY PRODUCE
BEAUTIFUL RESULTS.

THE BASICS

At a fundamental level, tapestry crochet is a technique for changing colors within a row or round while carrying and crocheting over the color that's not in use. This simple trick prevents "floats," or strands of yarn that stretch across the wrong side of your work as you switch back and forth between colors. By hiding the floats within the stitches, you create pieces that look good on both the right and wrong sides, and that are less likely to catch and snag **(Figure 1)**.

As in traditional Fair Isle knitting, I only ever work two colors in a single row, as do all the projects in this book. It is possible to use more than two colors, but this makes the resulting fabric very dense.

It's important to note that even when a row or section of your project calls for only one color, carry a second yarn strand to crochet over, preferably the same color as your main color. This will keep your gauge even throughout the project.

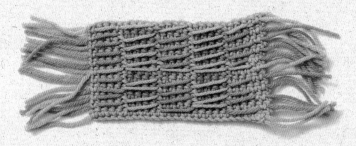

1
Crochet with floats on the back.

15

WORKING THROUGH THE BACK LOOP ONLY

Given the nature of crochet, it can be tricky to get your stitches to align perfectly in straight columns, from one row to the next. They always look a little skewed when you crochet through both loops **(Figure 1)**. To create better alignment, I always crochet through the back loop only, and I stitch only on the right side of the work **(Figure 2)**.

When you are looking at the top of your crochet stitch, you'll see two loops, front and back, that form a letter V **(Figure 3)**. To crochet through the back loop only, you'll insert your hook from front to back through the middle of the V and under the back loop, then proceed with your stitch.

Crocheting through the back loop leaves the front loop visible on the right side of your work, creating a little ridge. That ridge is important; it helps create the illusion that the stitches are lining up straight on top of each other.

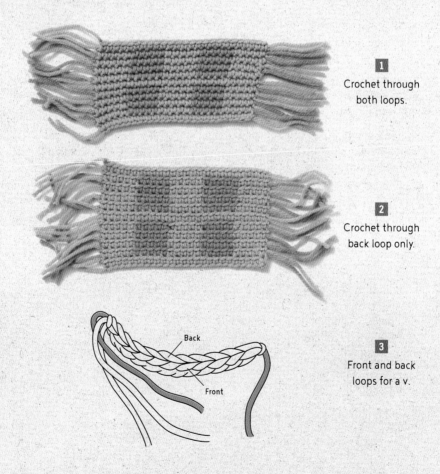

1
Crochet through both loops.

2
Crochet through back loop only.

Back

Front

3
Front and back loops for a v.

READING CHARTS & CHANGING COLORS

All of the projects in this book use colorwork charts to show you which colors to use and when. Reading the charts is simple: Read the chart from the bottom up, right to left. Each square of the chart equals one single crochet. The colors on the chart correspond to the colors used on the samples, and the exact colors are listed in each pattern.

When the next stitch on your chart shows a different color, it's time to switch yarns. Pay attention to these color changes. You'll need to end the previous stitch with your new color. For example, to change from color A to color B, you will work your last color A stitch as follows:

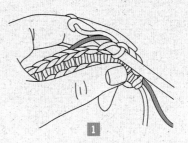

1 | Insert the hook in the back loop of the stitch and yarn over the hook with color A **(Figure 1)**.

2 | Pull the loop through the stitch. You now have two loops of color A on your hook.

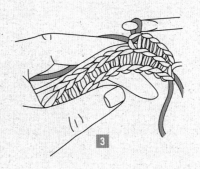

3 | Drop color A to the back of your work and yarn over with color B **(Figure 2)**.

4 | Pull color B through both loops **(Figure 3)**.

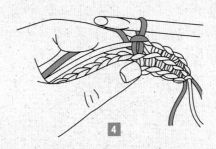

5 | You're now ready to work your next stitch with color B **(Figure 4)**.

WORKING TAPESTRY CROCHET FLAT

When you're working on flat projects, such as the Distant Mountains throw, you will always work on the right side of your fabric. To do this, you'll have to cut your yarn after every row and begin again on the right side of the project.

1 | Start each row with a slipknot on your hook of the color called for in your pattern. Leave a long tail of indicated length **(Figure 1)**.

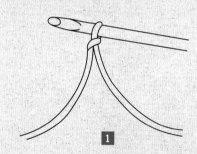

2 | Lay your second color behind the work, also leaving a tail **(Figure 2)**.

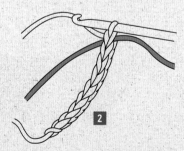

3 | Work your first stitch with your main color as instructed, crocheting over the second color **(Figure 3)**.

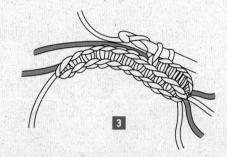

4 | Continue working across the row as instructed. When you get to the last stitch, fasten off your yarn and cut both colors, leaving long tails on both **(Figure 4)**.

5 | Do not turn your work. Begin with new strands of yarn at the next row on the right side, working from right to left in the same manner.

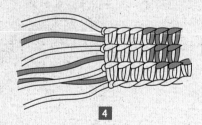

WORKING TAPESTRY CROCHET IN THE ROUND

Crocheting in the round lends itself perfectly to tapestry crochet because, as you work in rounds, you're always crocheting on the right side of the fabric. For the projects in this book, you won't join your rounds (unless specified), but instead continue to work around in a spiral. It's best to use a stitch marker to mark the beginning of your round.

To tapestry crochet in the round, you'll crochet over your second color until you need it, just as you do when working flat. When you get to the end of a round, don't turn your work, but simply continue crocheting to start the next round. If the next round uses the same two colors as the previous round, you won't need to break your yarn; you can simply keep working. If the round does require different colors, break one or both yarns as needed and join the new colors for the next round.

GAUGE & TENSION

Your gauge in tapestry crochet will be different than with regular crochet, so it is important to test your gauge before you start a project. To create a swatch for a project worked in the round, simply make a swatch using the method for flat tapestry crochet. Since you only work on the right side of the flat piece, your stitches will be the same gauge as if you were working in the round.

You can also use your test swatch to make sure your tension is correct. When carrying the second color along your work, make sure you don't pull the carried yarn too tight. This will cause your project to bunch up or pull in **(Figure 1)**. On the other hand, if the carried yarn is too loose, it may show through your stitches **(Figure 2)**. Practicing on your gauge swatch is a great way to make sure you have the correct tension before starting your project.

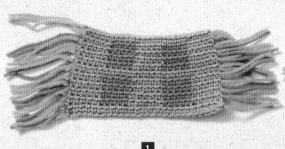

1

Carried yarn pulled too tight.

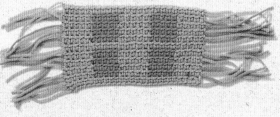

2

Carried yarn too loose.

FINISHING

The finishing techniques you'll use for the projects in this book are much the same as any other crochet project. You'll need to weave in the ends and block your project to get the best results. Because the projects worked flat require you to cut your yarn at the end of each row, you'll have a lot of ends to deal with.

Many of the projects suggest using the ends as fringe. To make a fringe, you'll simply tie the ends into knots, creating small tassels. Decide how many ends you want in each tassel, then wrap the yarn around your fingers and pull the tails through the middle.

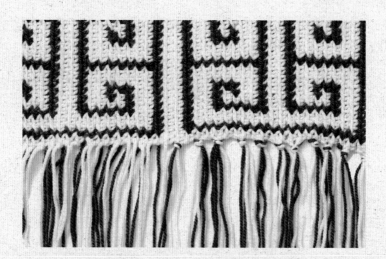

On the left, the ends hang loose.
On the right, they are knotted
together to create neat fringe.

BLOCKING

I find that all the projects in this book benefit from blocking. Feel free to use your favorite technique or experiment with different blocking techniques, such as steaming and wet-blocking. I prefer to pin out my finished object on a blocking board, gently spray it with lukewarm water so that it is damp but not saturated, and let it air-dry. You can block socks, but if you plan on making many socks, it may be worth investing in sock blockers—they will help block your socks into the appropriate shape and size.

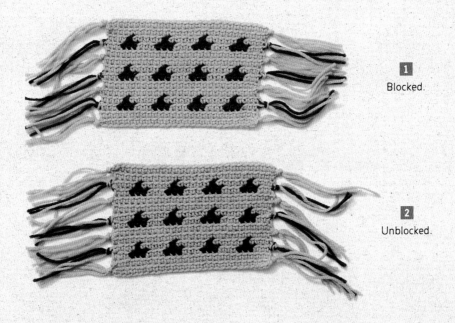

1
Blocked.

2
Unblocked.

HIT THE ROAD

PROJECTS

>>>>>>>>>>>>>>>>>>>>>

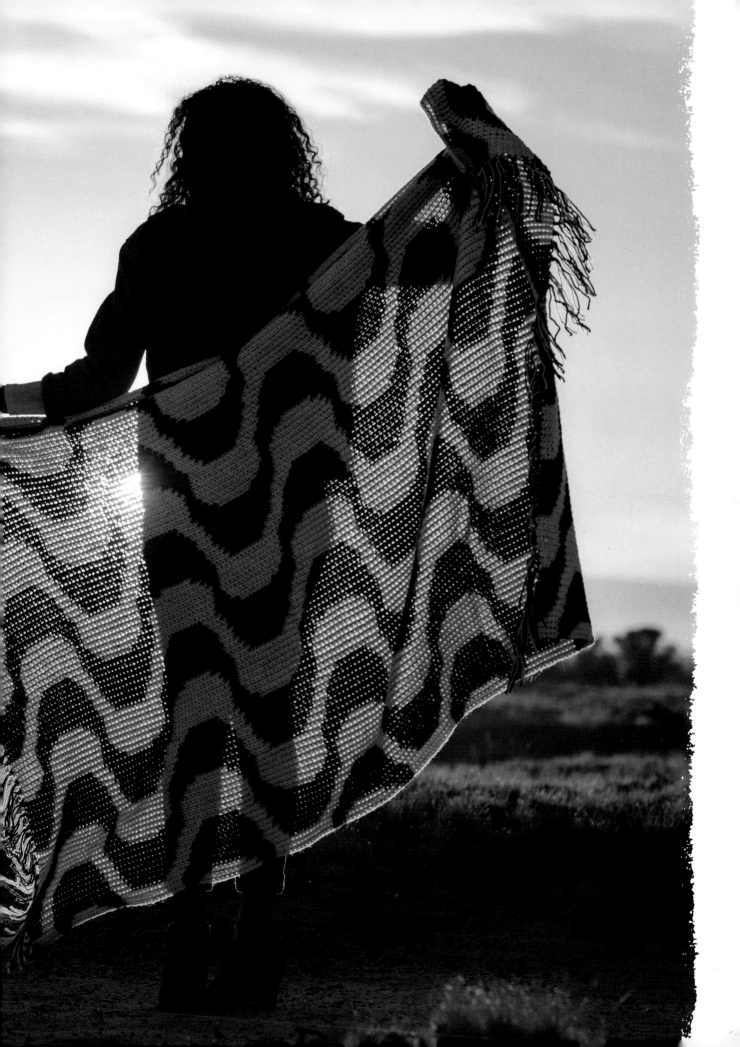

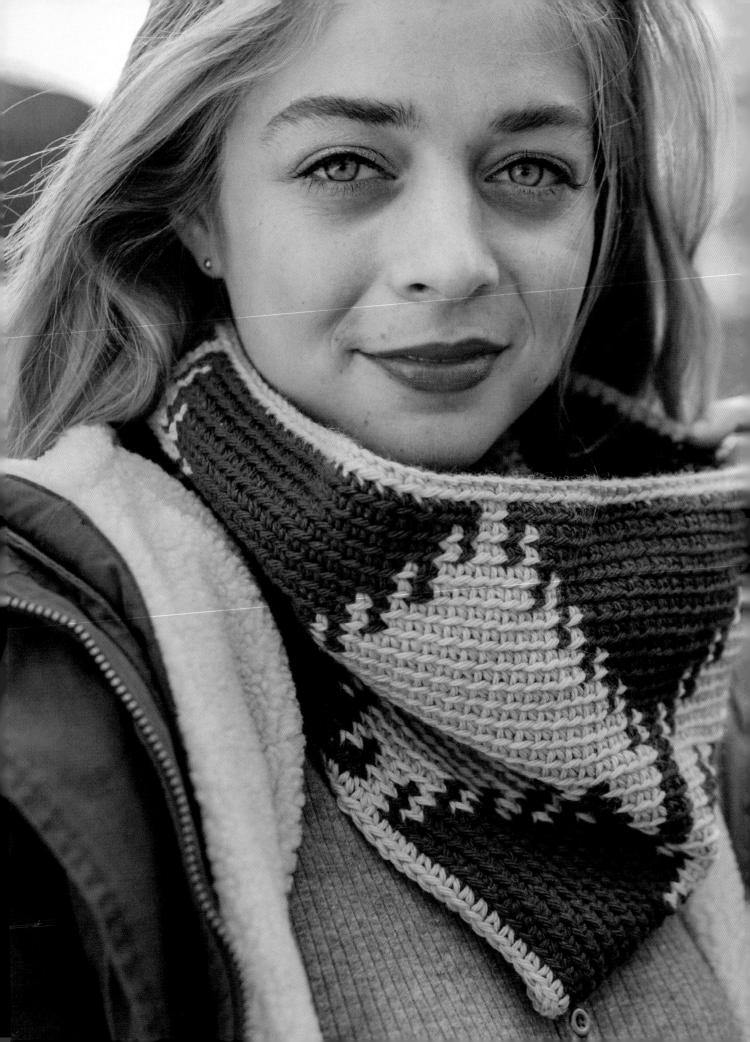

READY FOR ADVENTURE

SCARVES, SHAWLS, & COWLS

>>>>>>>>>>>>>>>>>>>>>

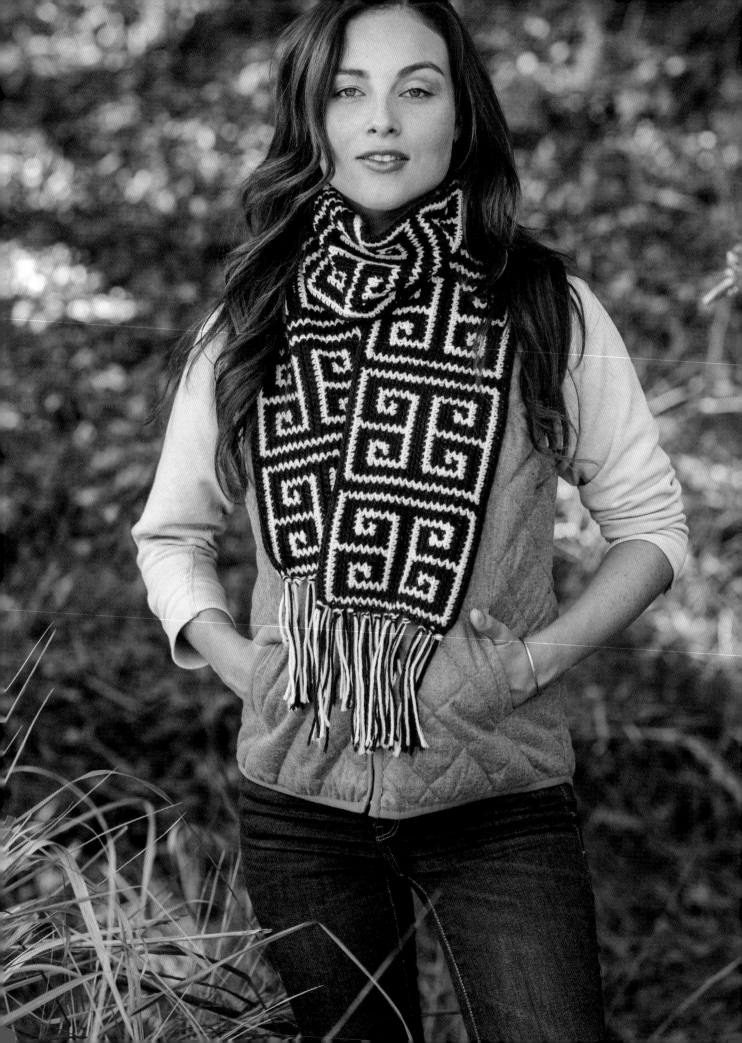

ROUTE MAPS SCARF

>>>>>>>>>>>>>>>>>>>>

WITH ITS BOLD, GRAPHIC DESIGN, THIS SCARF MAKES A
STATEMENT AND KEEPS YOU WARM NO MATTER WHERE YOU
GO. IT'S EASY TO MODIFY THE LENGTH TO SUIT YOUR STYLE BY
SIMPLY ADDING OR REMOVING PATTERN REPEATS.

FINISHED SIZE

Scarf measures 64¼" (163 cm)
long (excluding fringe) and 6"
(15 cm) wide.

YARN

Worsted weight (#4 Medium).
Shown here: Berroco Vintage
(52% acrylic, 40% wool, 8%
nylon; 218 yd [199 m]/3½ oz
[100 g]): #51182 Indigo (A) and
#5100 Snow Day (B), 1 skein each.

HOOK

Size U.S. 7 (4.5 mm).

*Adjust hook size if necessary to
obtain correct gauge.*

NOTIONS

Stitch markers.

GAUGE

17 sc blo and 14 rows = 4" (10 cm).

NOTES

+ You will always start with A and
carry a strand of B.

+ Leave a 9" (23 cm) tail at the
beginning and end of each row in
each color. These tails will become
the fringe.

+ Always crochet on the right side
of your work, from right to left.

+ Start each row with a
slipknot on your hook.

+ To adjust the length of your
scarf, adjust the length of your
beginning chain, adding or
subtracting multiples of 21.

+ Use stitch markers between
the chart repeats.

INSTRUCTIONS

With A, ch 274 (this will give you 13 pattern reps).

Row 1: With A, working in back ridge loop of ch, sc in 2nd ch from hook and each ch across—273 sts.

Rows 2–22: Work Rows 1–21 of chart, working 21-st pattern rep 13 times across; fasten off.

Finishing

Tie the ends of 2 rows together to create fringe

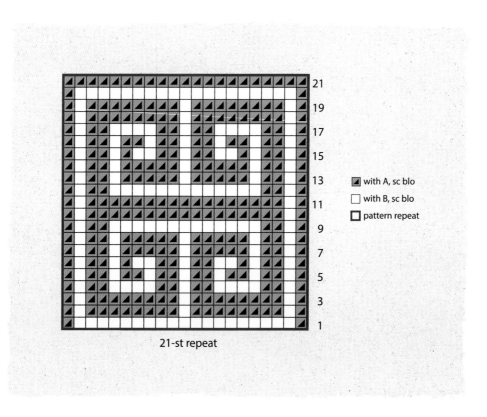

with A, sc blo

with B, sc blo

pattern repeat

21-st repeat

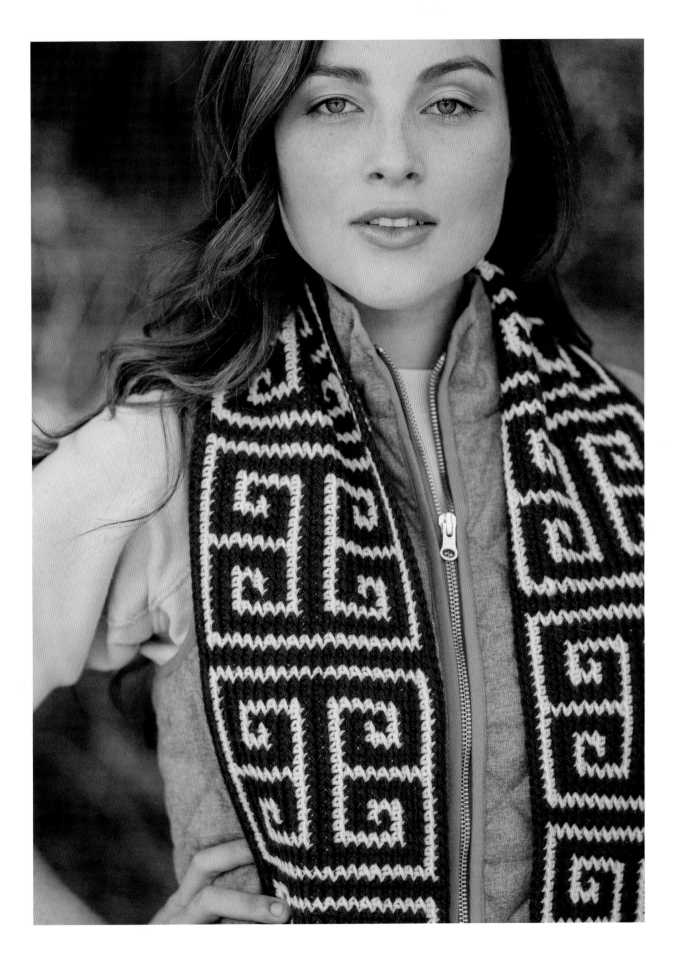

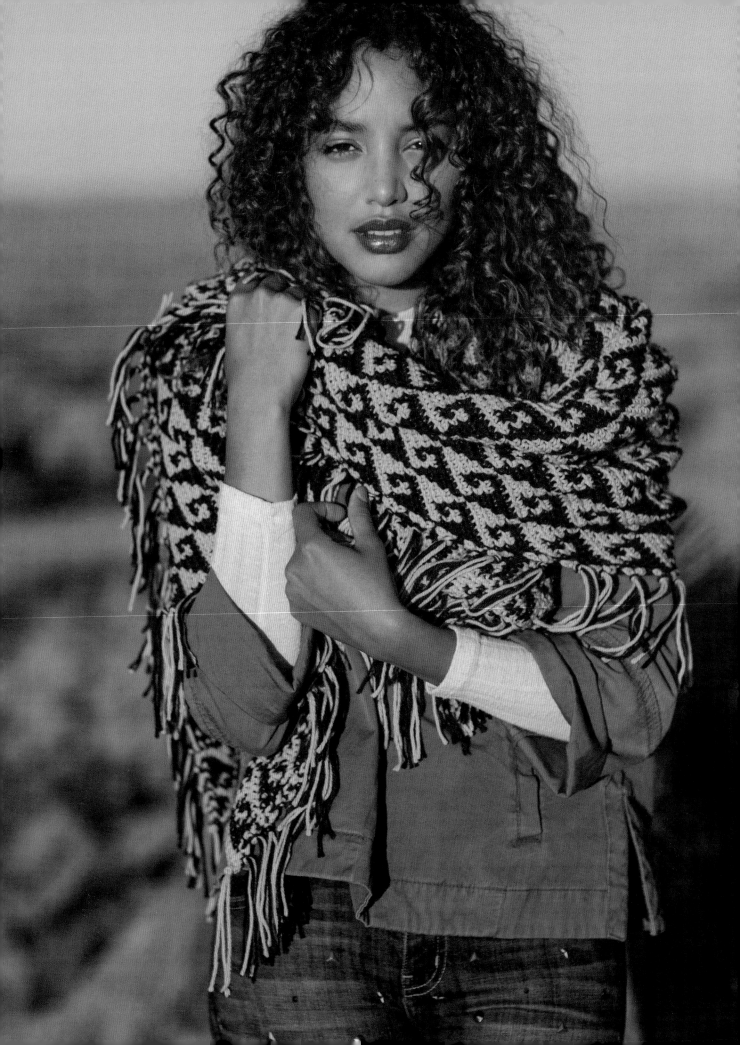

WEST WIND SHAWL

>>>>>>>>>>>>>>>>>>>>>>

JUST IN CASE A CHILL BLOWS IN, A SHAWL IS AN EVER-
USEFUL ACCESSORY TO HAVE AT HAND. WRAP THIS ONE
AROUND YOUR SHOULDERS TO WARM UP AND ADD A
CONFIDENT, GRAPHIC STATEMENT TO YOUR LOOK.

FINISHED SIZE

Shawl measures about 74"
(188 cm) wide along top
edge and 34" (86.4 cm) tall
(excluding fringe).

YARN

Worsted weight (#4 Medium).
Shown here: Berroco Vintage
(52% acrylic, 40% wool, 8%
nylon; 218 yd [199 m]/3½ oz
[100 g]): #5116 Dove (A) and
#5182 Black Currant (B), 2
skeins each.

HOOK

Size U.S. 7 (4.5 mm).

*Adjust hook size if necessary to
obtain correct gauge.*

NOTIONS

Stitch markers.

GAUGE

16 sc blo and 12 rows = 4" (10 cm).

NOTES

+ You will always start with A
and carry the accent color.

+ Leave a 6" (15 cm) tail at the
beginning and end of each row in
each color. These tails will become
the fringe.

+ Always crochet on the right side
of your work, from right to left.

+ Start each row with a slipknot
on your hook.

+ Use stitch markers between the
chart repeats.

+ The last stitch of every row is left
unworked. This decrease gives the
shawl its triangular shape.

INSTRUCTIONS

With A, ch 171.

Row 1: Working in back loop of ch, sc in 2nd ch from hook and each ch across—170 sc.

Rows 2-9: Work Rows 1–8 of chart, beg with 1st 8 sts, then working 8-st pattern rep 19 times across, ending with last sts of chart—8 sts dec'd.

Rows 10-153: Repeat Rows 2–9 eighteen more times, working 1 less pattern rep per rep—18 sts rem.

Rows 154-168: Work Rows 9–24 of chart—2 sts rem; fasten off.

Finishing

Tie ends of 2 rows together to create fringe.

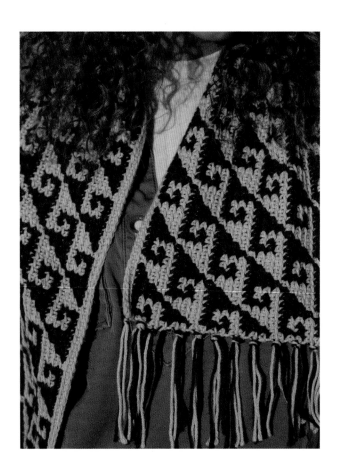

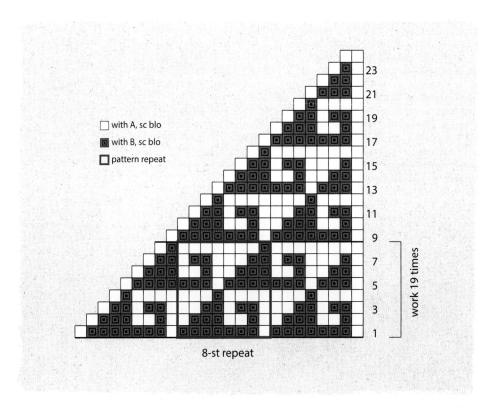

with A, sc blo
with B, sc blo
pattern repeat

work 19 times

8-st repeat

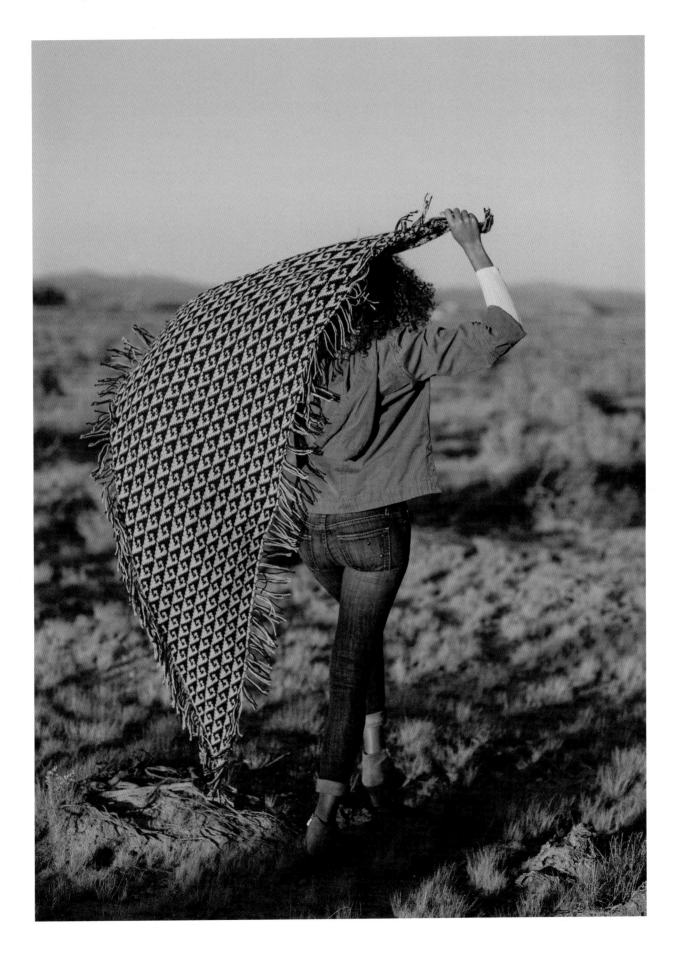

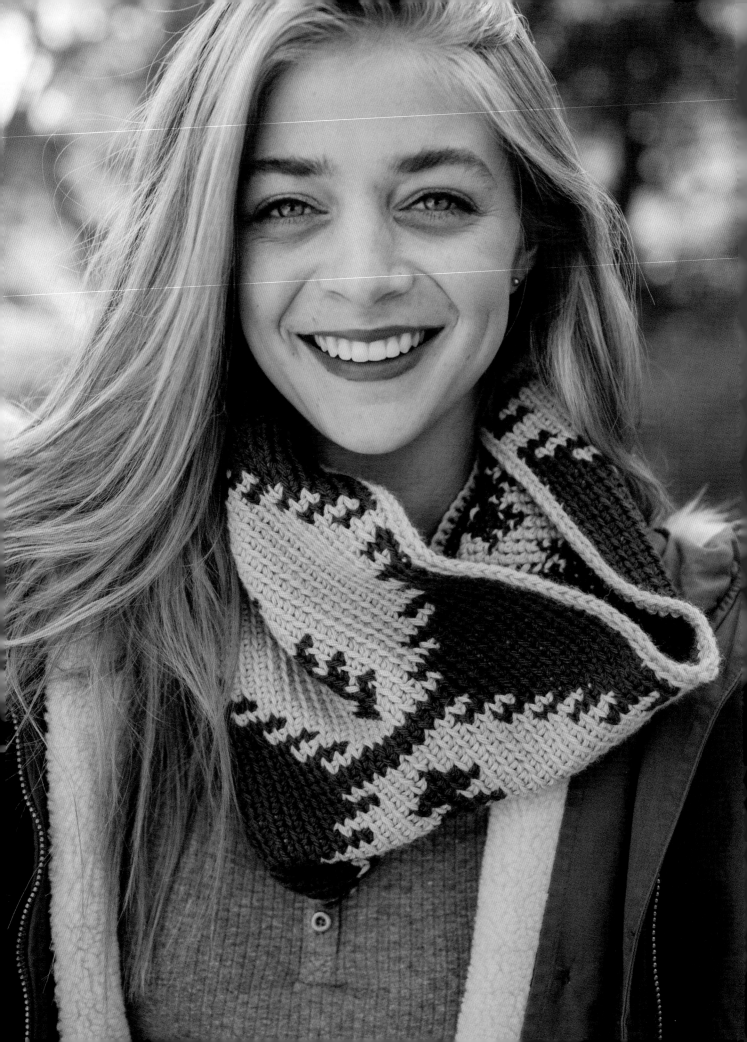

EVERGREEN COUNTRY COWL

>>>>>>>>>>>>>>>>>>>>

THE ANGULAR SHAPES OF THIS DESIGN ECHO THE
SILHOUETTES OF EVERGREEN TREES YOU CAN FIND JUST
ABOUT ANYWHERE. THIS COWL IS A QUICK, SATISFYING
PROJECT AND IS A COMFY ADDITION TO ANY OUTFIT.

FINISHED SIZE
Cowl measures 26½" (67.5 cm)
in circumference and 9½"
(24 cm) tall.

YARN
Worsted weight (#4 Medium).
Shown here: Berroco Vintage
(52% acrylic, 40% wool, 8%
nylon; 218 yd [199 m]/3½ oz
[100 g]): #5104 Mushroom
(A) and #5152 Mistletoe (B).
1 skein each.

HOOK
Size U.S. 7 (4.5 mm).

*Adjust hook size if necessary
to obtain correct gauge.*

NOTIONS
Stitch markers; tapestry needle.

GAUGE
17 sc blo and 15 rows = 4" (10 cm).

NOTES
✦ The cowl is worked in continuous
rounds. Use stitch markers to mark
the end of each round.

✦ The cowl is worked in single
crochet through the back loop only.

✦ You will carry a second strand of
yarn on all rounds. On solid rounds,
carry the same color of yarn.

INSTRUCTIONS

With A, ch 112, sl st in 1st ch to join to form a ring, being careful not to twist ch.

Rnd 1: Ch 1, working in the back of the loop, sc in each st around —112 sc.

Rnds 2–34: Work Rows 1–33 of chart, working 28-st pattern rep 4 times around.

Rnd 35: With A, sc in each st around, sl st in 1st sc to join; fasten off.

Finishing

Weave in ends.

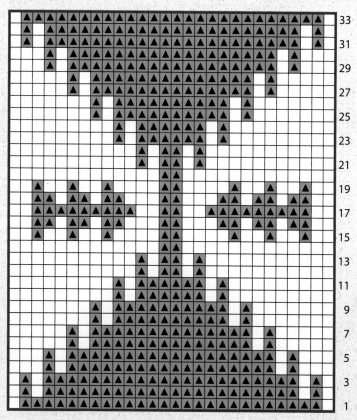

28-st repeat

☐ with A, sc blo
▲ with B, sc blo
☐ pattern repeat

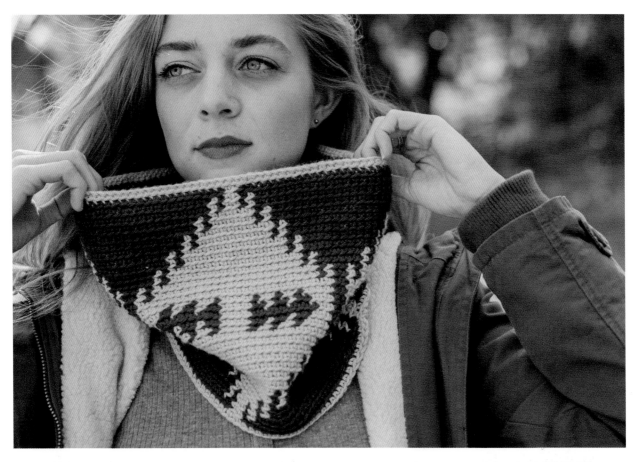

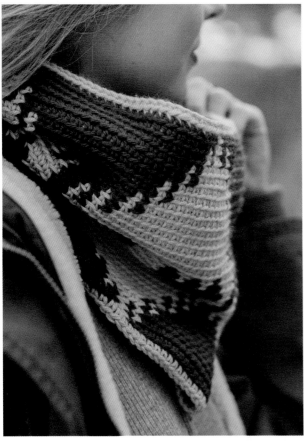

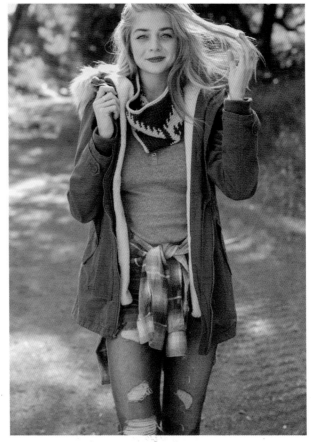

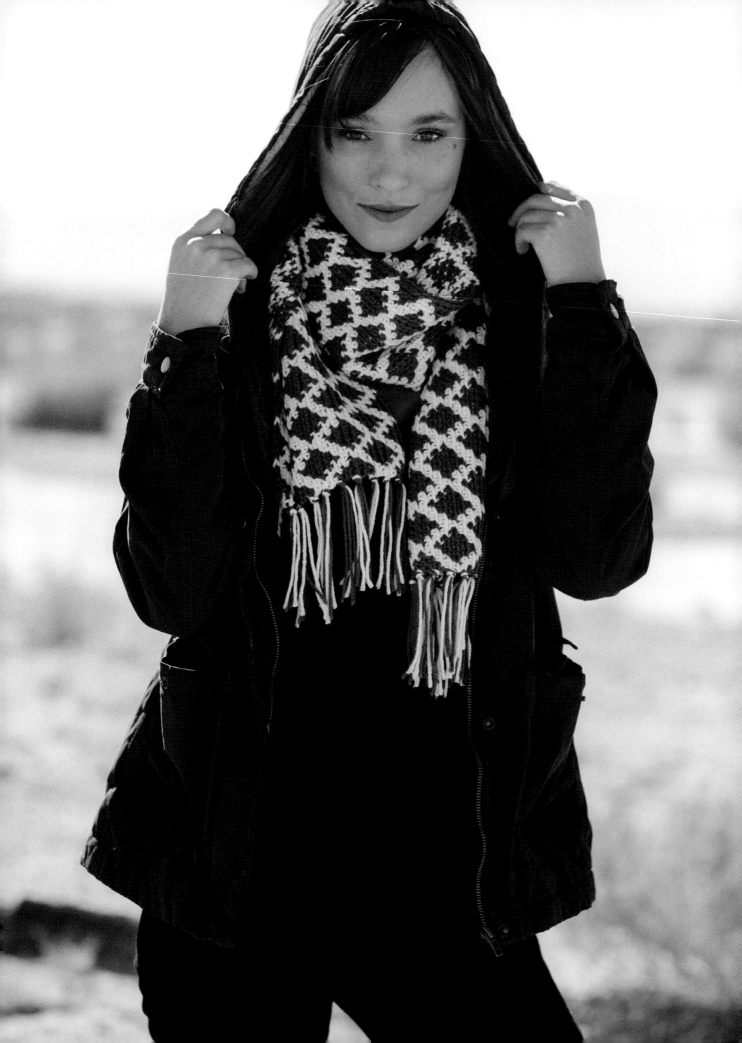

CROSSROADS SCARF

>>>>>>>>>>>>>>>>>>>

THIS SCARF ADDS A PRETTY POP OF PATTERN TO ANY TRAVEL ENSEMBLE. JUST WRAP IT AROUND YOUR NECK AND YOU'LL STAY WARM AS YOU ZIG-ZAG YOUR WAY TOWARD ADVENTURE.

FINISHED SIZE

Scarf measures 74" (188 cm) long (excluding fringe) and 6½" (16.5 cm) wide.

YARN

Worsted weight (#4 Medium). *Shown here*: Berroco Vintage (52% acrylic, 40% wool, 8% nylon; 218 yd [199 m]/3½ oz [100 g]): #5130 Taupe (A) and #5101 Mochi (B), 1 skein each.

HOOK

Size U.S. G/6 (4 mm).

Adjust hook size if necessary to obtain correct gauge.

NOTIONS

Stitch markers.

GAUGE

15 sc blo and 13 rows = 4" (10 cm).

NOTES

+ Leave a 9" (23 cm) tail at the beginning and end of each row in each color. These tails will become the fringe.

+ Always crochet on the right side of your work from right to left.

+ Start each row with a slipknot on your hook.

+ To adjust the length of your scarf, adjust the length of your beginning chain, adding or subtracting multiples of 6. Work additional chart repeats to add width.

+ Use stitch markers between the chart repeats.

INSTRUCTIONS

With A, ch 278.

Row 1: Working through the back of the loop, work Row 1 of chart, placing 1st sc in 2nd ch from hook, then sc in each ch across, working 6-st pattern rep 46 times across, then work last st of chart—277 sc.

Rows 2–21: Work Rows 2–8 of chart, then work Rows 1–8 once more, then work Rows 1–5 once more.

Finishing

Tie the ends of 3 rows together to create fringe.

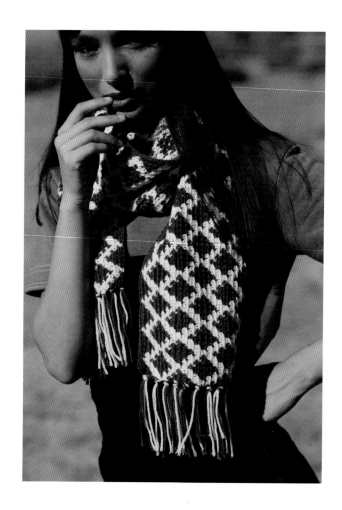

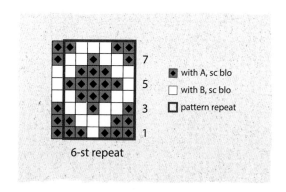

◆ with A, sc blo
☐ with B, sc blo
☐ pattern repeat

6-st repeat

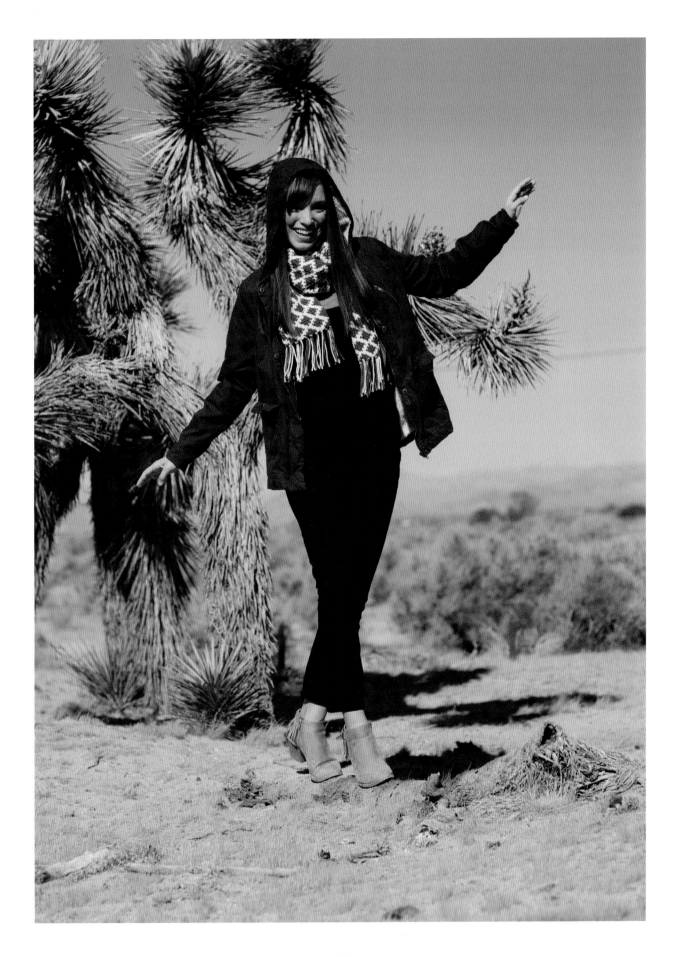

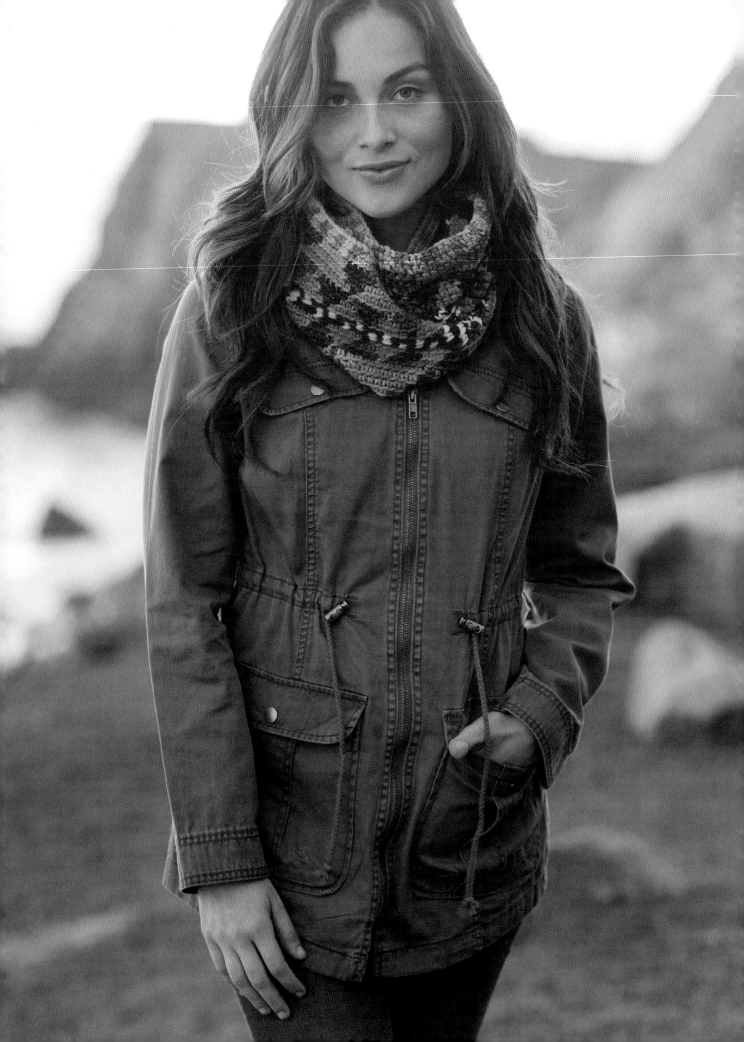

LANDSCAPE COWL

›››››››››››››››››››››

MAKE A STATEMENT AS YOU TAKE IN THE VIEW.
THIS COLORFUL COWL CAN BE WRAPPED DOUBLE
FOR EXTRA WARMTH, OR DRAPED LONG FOR A MORE
DRAMATIC LOOK.

FINISHED SIZE

Cowl measures 51½" (131 cm) in circumference and 6½" (16.5 cm) long.

YARN

Aran weight (#4 Medium). *Shown here*: Malabrigo Twist (100% baby merino; 150 yd [137 m]/3½ oz [100 g]): #613 Zinc (A), #130 Damask (B), #96 Sunset (C), #150 Azul Profundo (D), #63 Natural (E), #56 Olive (F), 1 skein each.

HOOK

Size U.S. H/8 (5 mm).

Adjust hook size if necessary to obtain correct gauge.

NOTIONS

Stitch markers; tapestry needle.

GAUGE

14 sc blo and 12 rows = 4" (10 cm).

NOTES

✦ The cowl is worked in continuous rounds. Use stitch markers to mark the end of each round.

✦ The cowl is worked in single crochet through the back loop only.

INSTRUCTIONS

With A, ch 180, sl st in 1st ch to join to form a ring, being careful not to twist the ch.

Rnd 1: Working in back of the loop of ch, work Row 1 of chart, working 12-st pattern rep 15 times around—180 sc.

Rnds 2–19: Work Rows 2–19 of chart; fasten off.

Finishing

Weave in ends.

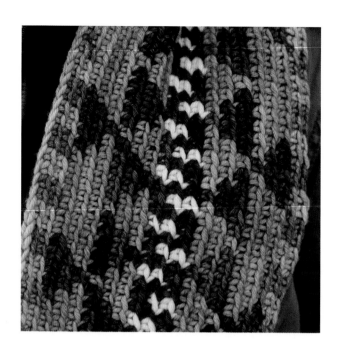

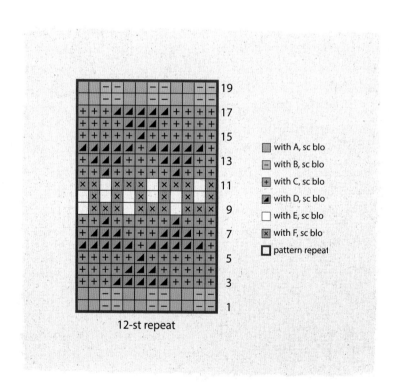

12-st repeat

with A, sc blo
with B, sc blo
with C, sc blo
with D, sc blo
with E, sc blo
with F, sc blo
pattern repeat

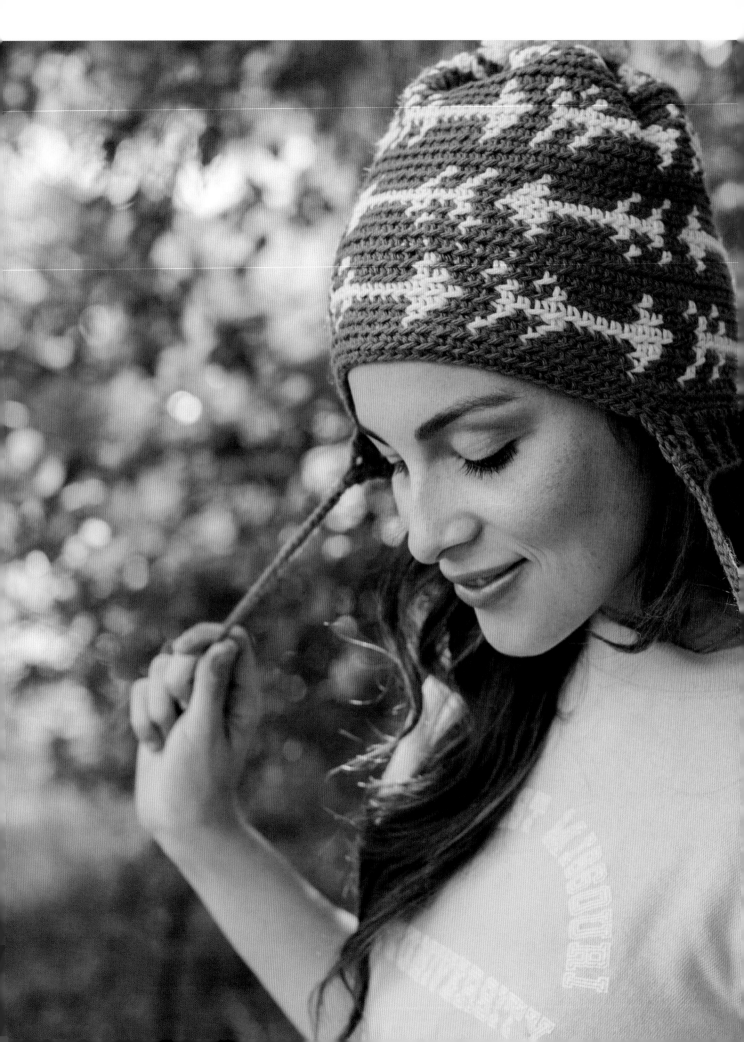

ENJOY THE RIDE

HATS & HEADBANDS

>>>>>>>>>>>>>>>>>>>>>

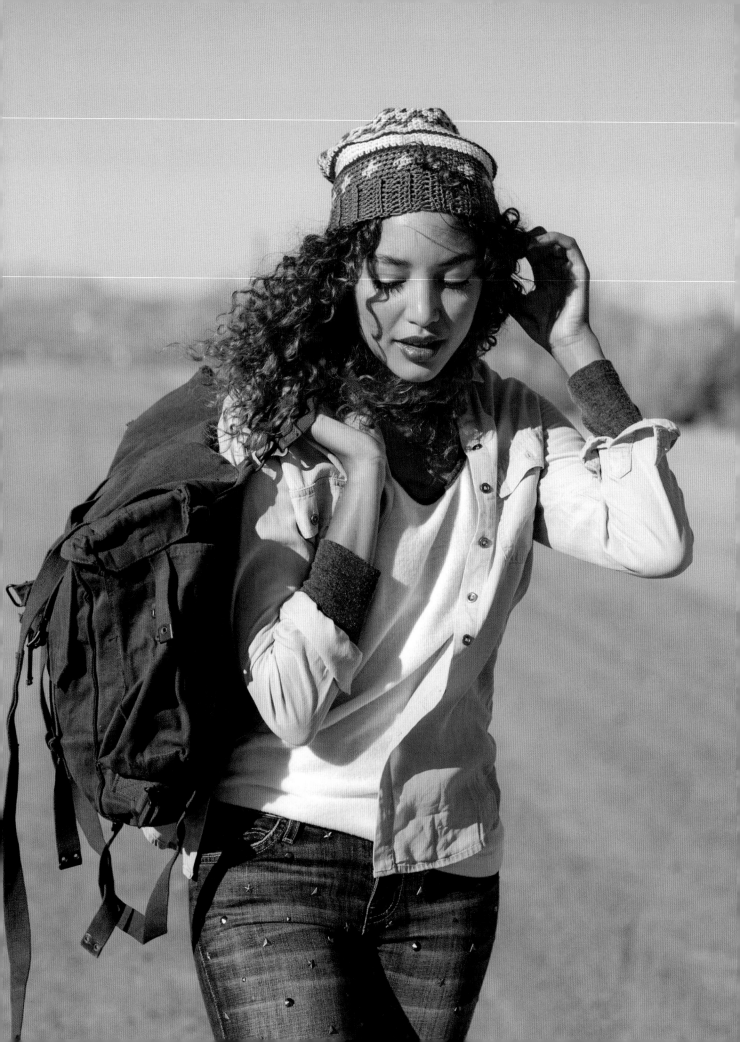

HORIZON HAT

>>>>>>>>>>>>>>>>>>

ROAD TRIPS ARE ALL ABOUT POSSIBILITY, AND
THIS HAT JUST ADDS TO THE FUN. THIS VERSION IS
WORKED IN FOUR COLORS, BUT IT COULD EASILY BE
WORKED IN TWO OR THREE.

FINISHED SIZE

Hat measures 20" (51 cm) in
circumference and 10" (25.5 cm)
tall. Fits a 21" (53.5 cm) to 23"
(58.5 cm) head.

YARN

Worsted weight (#4 Medium).
Shown here: Lion Brand 24/7
Cotton (100% mercerized cotton;
186 yd [170 m]/3½ oz [100 g]):
#150 Charcoal (A), #107 Sky (B),
#113 Red (C), and #157 Lemon
(D), 1 skein each.

HOOK

Size U.S. 7 (4.5 mm).

*Adjust hook size if necessary
to obtain correct gauge.*

NOTIONS

Stitch markers; tapestry needle.

GAUGE

16 sc blo and 14 rows = 4" (10 cm).

NOTES

+ The hat is worked from
the brim up.

+ The brim is worked flat, then
the ends are sewn together to
form a ring.

+ The hat body is worked in
continuous rounds. Use stitch
markers to mark the end of each
round.

+ The hat body is worked in single
crochet through the back loop only.

+ You will carry a second strand of
yarn on all hat-body rounds. On
solid rounds, carry the same color
of yarn.

INSTRUCTIONS

Brim

With A, ch 11.

Row 1: Hdc in 3rd ch from hook and each ch across, turn—9 hdc.

Rows 2–40: Ch 2, hdc blo in each st across, turn; do not fasten off.

Using the tapestry needle, sew Row 1 and Row 40 together to form a ring to create the Brim. Fasten off.

Body

Rnd 1: Join A with sl st in Brim seam, ch 1, work 2 sc in each row-end of the Brim; do not join, place a st marker at the end of the rnd—80 sc.

Rnds 2–23: Working in the back of the loop only, work Rows 1–22 of chart, working 5-st pattern rep 16 times around.

Crown

Continue with D only.

Rnd 1: [Sc in next 6 sts, sc2tog] 10 times—70 sc rem.

Rnd 2: [Sc in next 5 sts, sc2tog] 10 times—60 sc rem.

Rnd 3: [Sc in next 4 sts, sc2tog] 10 times—50 sc rem.

Rnd 4: [Sc in next 3 sts, sc2tog] 10 times—40 sc rem.

Rnd 5: [Sc in next 2 sts, sc2tog] 10 times—30 sc rem.

Rnd 6: [Sc in next st, sc2tog] 10 times—20 sc rem.

Rnd 7: Sc2tog 10 times—10 sc rem.

Break yarn and draw tail through rem sts. Pull tight to gather sts and fasten off on wrong side.

Finishing

Weave in ends.

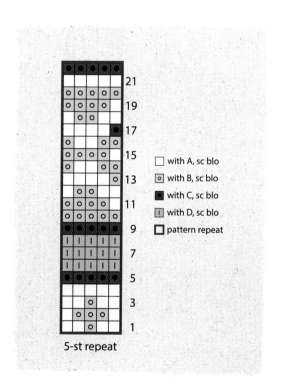

with A, sc blo

with B, sc blo

with C, sc blo

with D, sc blo

pattern repeat

5-st repeat

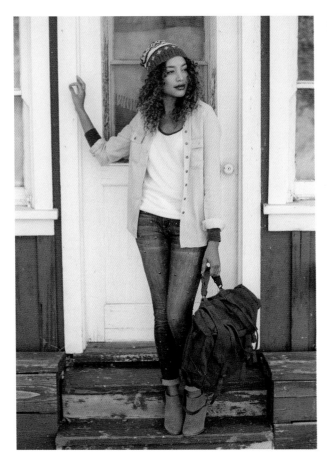
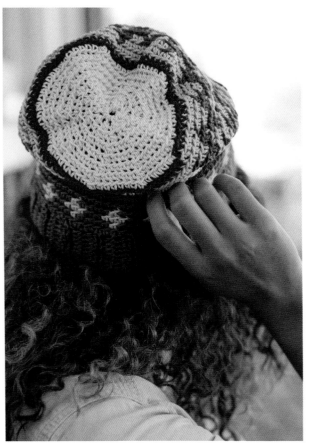
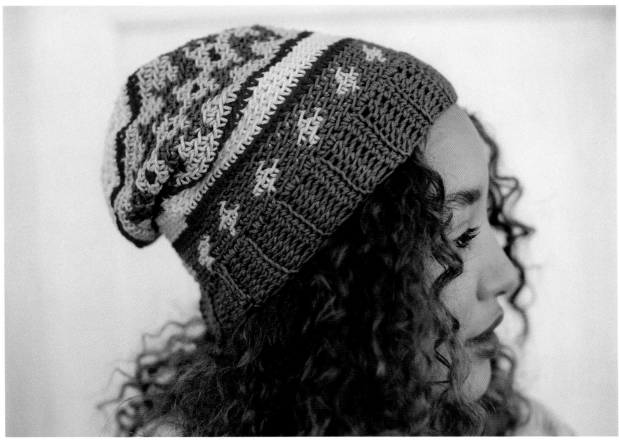

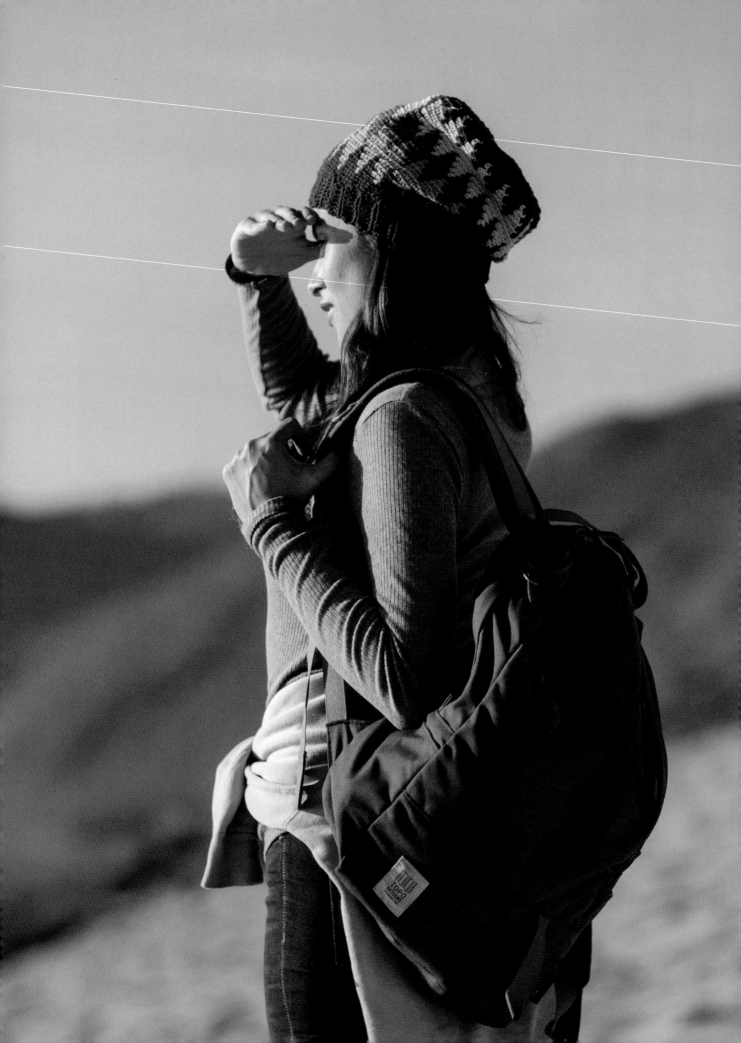

POINT A SLOUCH

>>>>>>>>>>>>>>>>>>>>>

TAKING INSPIRATION FROM TALL, RUGGED MOUNTAINS,
THIS HAT BOASTS A COLORFUL, STEEPLY PEAKED MOTIF.
WEAR IT AROUND TOWN OR EVEN ON A CHALLENGING HIKE
TO LOOK COOL AND STAY WARM.

FINISHED SIZE

Hat measures 20" (51 cm) in circumference and 14" (35.5 cm) tall. Fits a 21" (53.5 cm) to 23" (58.5 cm) head.

YARN

Worsted weight (#4 Medium). *Shown here:* Quince & Co. Lark (100% American wool; 134 yd [123 m]/1¾ oz [50 g]): Peacock (A), Belize (B), Storm (C), and Frost (D), 1 skein each; or Bark (A), Carrie's Yellow (B), Frost (C), Dogwood (D), 1 skein each.

NOTIONS

Stitch markers; tapestry needle.

HOOK

Size U.S. G/6 (4 mm); U.S. J/10 (6 mm).

Adjust hook size if necessary to obtain correct gauge.

GAUGE

18 sc blo and 14 rows = 4" (10 cm) with smaller hook.

NOTES

+ The hat is worked from the brim up.

+ The brim is worked flat, then the ends are sewn together to form a ring.

+ The hat body is worked in continuous rounds. Use stitch markers to mark the end of each round.

+ The hat body is worked in single crochet through the back loop only.

+ You will carry a second strand of yarn on all hat-body rounds. On solid rounds, carry the same color of yarn.

INSTRUCTIONS

Brim

With A and larger hook, ch 9, leaving a long tail.

Row 1: Working in blo, sc in 2nd ch from hook and each ch across, turn—8 sc.

Rows 2–50: Ch 1, sc blo in each st across, turn; do not fasten off.

Using the tapestry needle and long beg tail, sew Row 1 and Row 50 together to form a ring to create the brim.

Body

Rnd 1: With A and smaller hook, ch 1, work 2 sc in each row-end of Brim; do not join, place a st marker at the end of rnd—100 sc.

Rnds 2–21: Work Rows 1–20 of chart, working 5-st pattern rep 20 times around; fasten off B, C, and D.

Crown

Continue with A only.

Rnd 1: [Sc in next 8 sts, sc2tog] 10 times—90 sc rem.

Rnd 2: [Sc in next 7 sts, sc2tog] 10 times—80 sc rem.

Rnd 3: [Sc in next 6 sts, sc2tog] 10 times—70 sc rem.

Rnd 4: [Sc in next 5 sts, sc2tog] 10 times—60 sc rem.

Rnd 5: [Sc in next 4 sts, sc2tog] 10 times—50 sc rem.

Rnd 6: [Sc in next 3sts, sc2tog] 10 times—40 sc rem.

Rnd 7: [Sc in next 2 sts, sc2tog] 10 times—30 sc rem.

Rnd 8: [Sc in next st, sc2tog] 10 times—20 sc rem.

Rnd 9: Sc2otg 10 times—10 sc rem.

Break yarn and draw tail through rem sts. Pull tight to gather sts and fasten off on wrong side.

Finishing

Weave in ends.

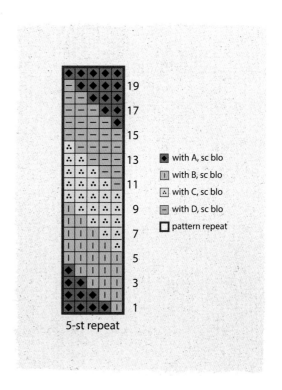

with A, sc blo
with B, sc blo
with C, sc blo
with D, sc blo
pattern repeat

5-st repeat

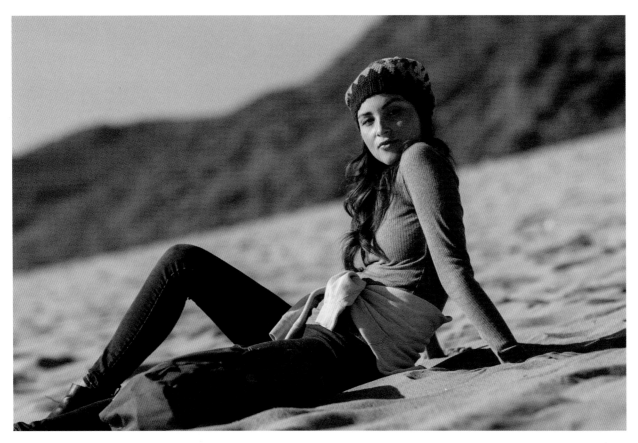

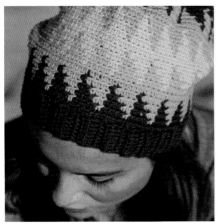

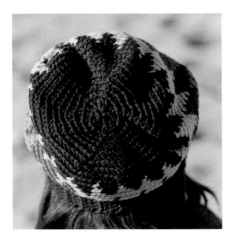

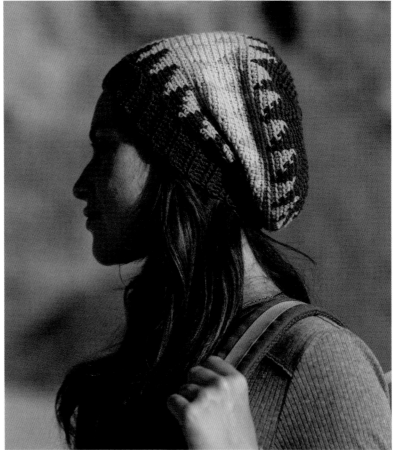

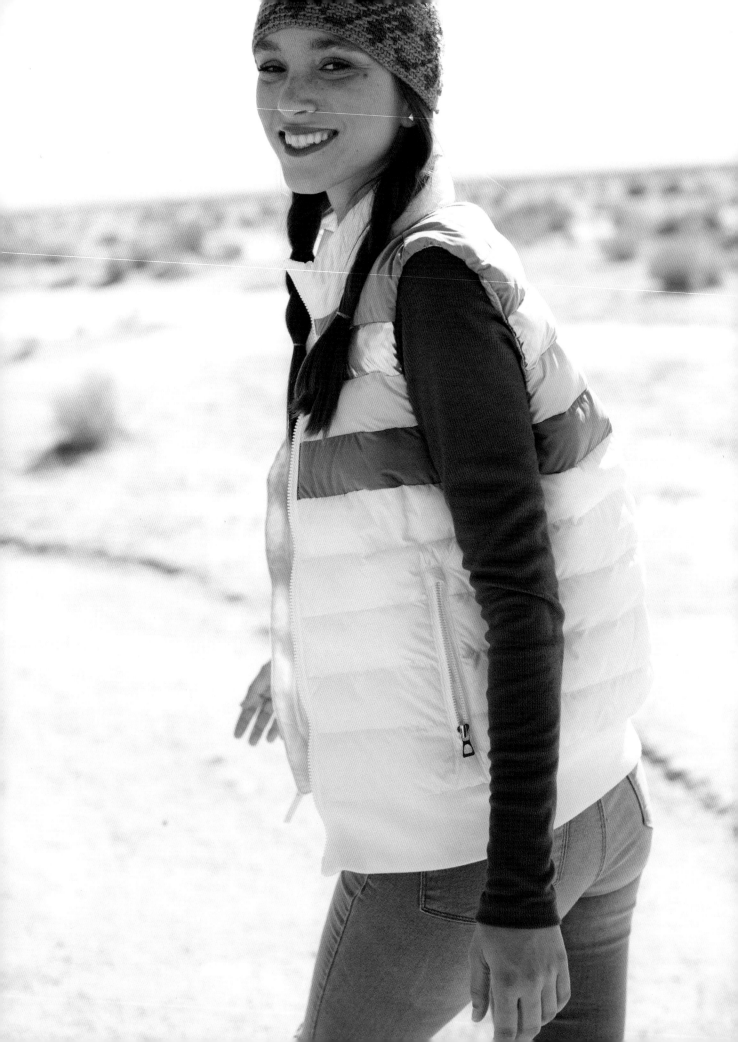

HAPPY TRAILS HEADBAND

>>>>>>>>>>>>>>>>>>>>>

AS ACCESSORIES GO, IT DOESN'T GET MUCH HAPPIER THAN
A CUTE EAR-WARMING HEADBAND FEATURING AN ADORABLE
ARGYLE PATTERN! SMALL AND SATISFYING TO STITCH, THIS
PROJECT IS AS FUN TO MAKE AS IT IS TO WEAR.

FINISHED SIZE

Headband measures 13½"
(34.5 cm) wide (without ends
and ties) and 3¾" (9.5 cm) tall.
One size fits all.

YARN

Worsted weight (#4 Medium).
Shown here: Knit Picks Wool of the
Andes Worsted (100% Peruvian
Highland wool; 110 yd [101 m]/3½
oz [50 g]): #25971 Wheat (A)
and #25652 Celestial (B), 1 skein
each; or #24275 Fairy Tale (A) and
#25986 Gosling (B), 1 skein each.

HOOK

Size U.S. G/6 (4 mm).

*Adjust hook size if necessary
to obtain correct gauge.*

NOTIONS

Stitch markers; tapestry needle.

GAUGE

18 sc blo and 14 rows = 4" (10 cm).

NOTES

+ Leave a 6" (15 cm) tail at the
beginning and end of each row
in each color.

+ You will always start with
A and carry the accent color.

+ Crochet on the right side of
your work, from right to left, when
working the headband portion.

+ The headband ends are
worked in turned rows.

+ Start each row with a slipknot
on your hook.

+ Use stitch markers between
the chart repeats.

INSTRUCTIONS

Headband

With A, ch 61.

Row 1: Sc in 2nd ch from hook and each ch across—60 sc.

Rows 2–12: Work Rows 1–11 of chart, working 12-st rep 5 times.

Row 13: With A, sc in each sts across; fasten off.

Headband End

Worked along short end of Headband.

Row 1: With RS facing, join A with sl st in right top corner of short end of Headband, ch 1, work 1 sc in each row-end, turn—13 sc.

Row 2: Ch 1, sc2tog, sc in next 9 sts, sc2tog, turn—11 sc rem.

Row 3: Ch 1, sc2tog, sc in next 7 sts, sc2tog, turn—9 sc rem.

Row 4: Ch 1, sc2tog, sc in next 5 sts, sc2tog, turn—7 sc rem.

Row 5: Ch 1, sc2tog, sc in next 3 sts, sc2tog, turn—5 sc rem.

Row 6: Ch 1, sc2tog, sc in next 2 sts—3 sc rem.

Ch 56, work 2 sc in 2nd ch from hook and in next 12 ch (creates a curl), then sc in each ch across, sl st in base of Row 6 to join. Fasten off.

Rep for other short end.

Finishing

Weave in ends.

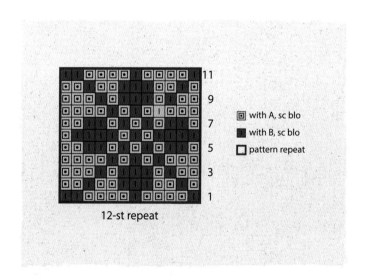

with A, sc blo
with B, sc blo
pattern repeat

12-st repeat

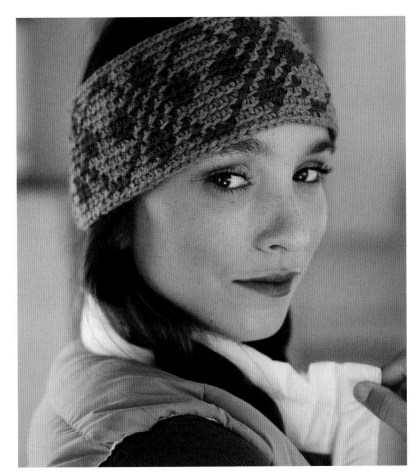

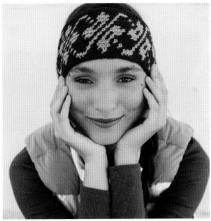

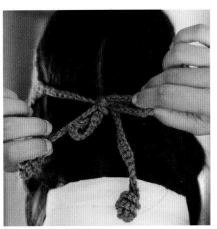

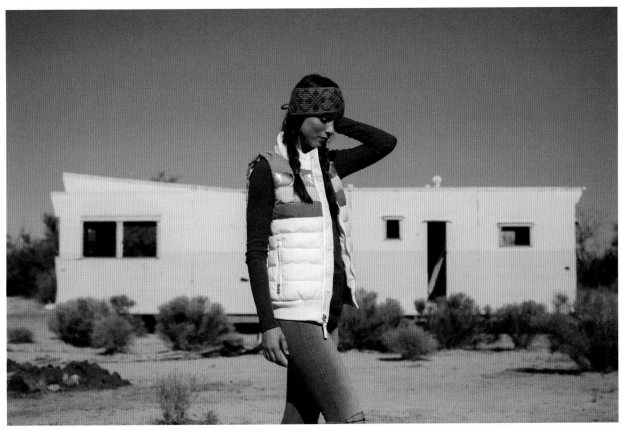

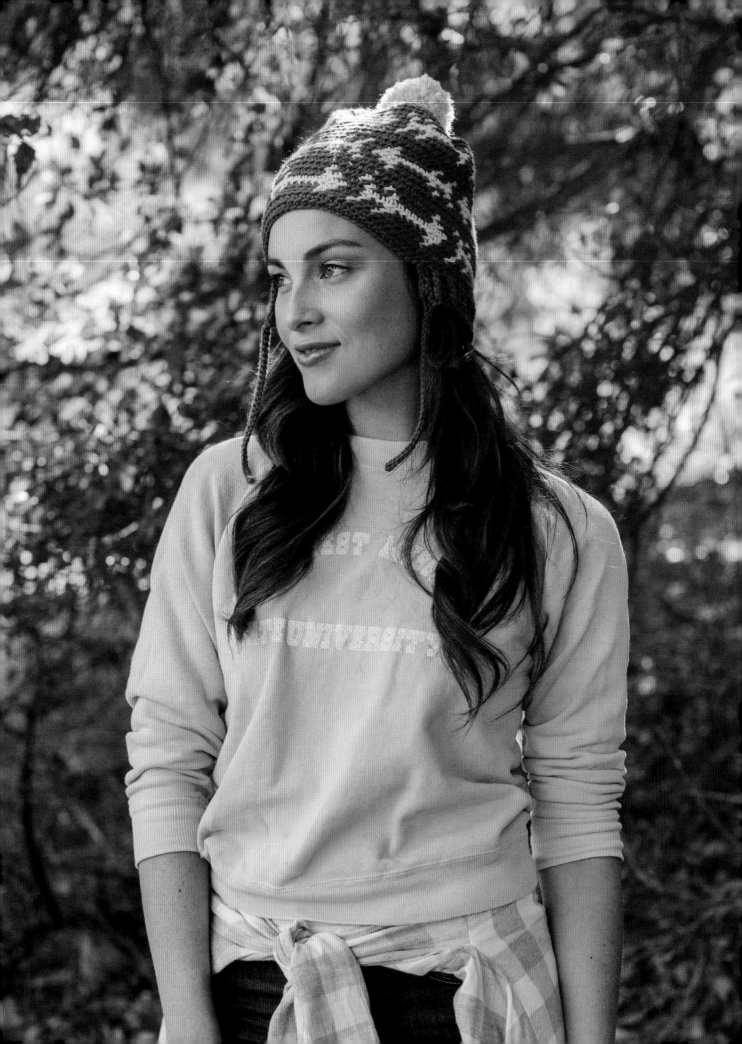

WAYFINDING HAT

>>>>>>>>>>>>>>>>>>>

SOMETIMES YOU JUST PICK A DIRECTION AND LEAVE
WHAT HAPPENS NEXT UP TO CHANCE. AND IF IT GETS COLD
ALONG THE WAY, THIS HAT WILL KEEP YOU EXTRA COZY WITH
A FLAP THAT COMES DOWN OVER THE EARS.

FINISHED SIZE

Hat measures 21" (53.5 cm) in circumference and 8" (20.5 cm) tall (excluding brim). Fits a 21" (53.5 cm) to 23" (58.5 cm) head.

YARN

Worsted weight (#4 Medium).
Shown here: Berroco Vintage (52% acrylic, 40% wool, 8% nylon; 218 yd [199 m]/3½ oz [100 g]): #5109 Storm (A) and #5113 Misty (B), 1 skein each; or #5122 Banane (A) and #5143 Dark Denim (B), 1 skein each.

HOOK

Size U.S. 7 (4.5 mm).

Adjust hook size if necessary to obtain correct gauge.

NOTIONS

Stitch markers; tapestry needle; pom-pom maker.

GAUGE

16 sc blo and 15 rows = 4" (10 cm).

NOTES

+ The hat is worked from the top down.

+ The hat body is worked in continuous rounds. Use stitch markers to mark the end of each round.

+ The brim is worked flat.

+ The body is worked in single crochet through the back loop only.

+ You will carry a second strand of yarn on all rounds. On solid rounds, carry the same color of yarn.

INSTRUCTIONS

Body

With A, ch 84, leaving a long tail, sl st in 1st ch to form a ring, being careful not to twist the ch.

Rnd 1: Ch 1, sc in each ch around—84 sc.

Rnd 2: Sc blo in each st around.

Rnds 3–7: Work Rows 1–5 of Right Arrow chart, working 14-st pattern rep 6 times around.

Rnds 8–9: With A, sc in each st around.

Rnds 10–14: Work Rows 1–5 of Left Arrow chart, working 14-st pattern rep 6 times around.

Rnds 15–16: With A, sc in each st around.

Rnds 17–30: Rep Rnds 3–16; do not fasten off.

Brim

Row 1: (RS) Ch 3 (counts as dc throughout), dc in next 52 sts, turn—53 dc.

Row 2: Ch 3, dc in next st, *BPdc in next, dc in next 2 sts; rep from * across, placing last dc in top of beg ch-3, turn.

Row 3: Ch 34, sl st in 2nd ch from hook and in next 30 ch, dc in next dc, *FPdc in next st, dc in next 2 sts; rep from * across, ch 31, sl st in 2nd ch from hook and in each ch across; fasten off.

Finishing

Weave beg tail through sts of Rnd 1. Pull tight to gather sts and fasten off on wrong side. With B, make a pompom and attach to the top of the hat. Weave in ends.

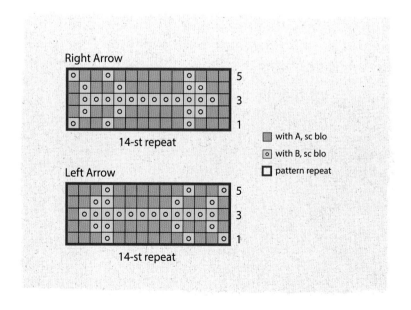

Right Arrow

5

3

1

14-st repeat

Left Arrow

5

3

1

14-st repeat

■ with A, sc blo

⊡ with B, sc blo

□ pattern repeat

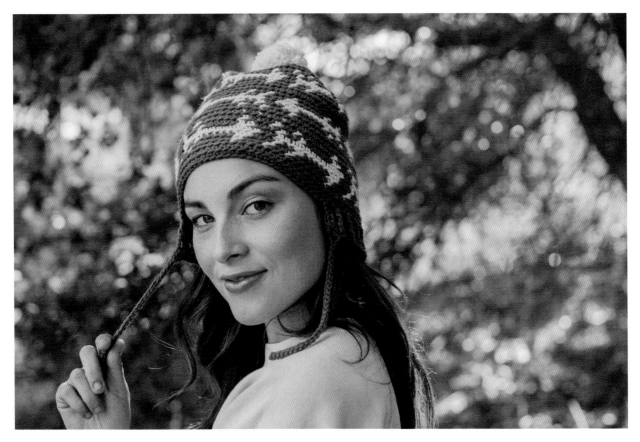

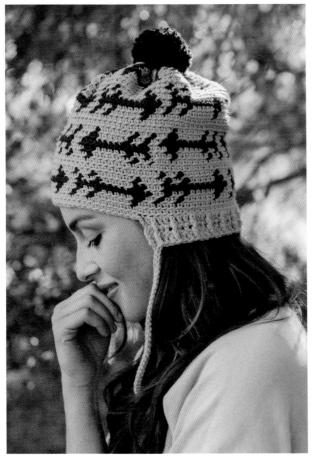

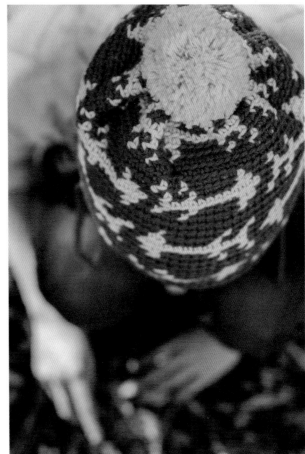

GARDEN DETOUR BEANIE

>>>>>>>>>>>>>>>>>>>>

WHETHER OR NOT A VISIT TO A LUSH GARDEN FACTORS
INTO YOUR PLANS, THIS BEANIE CAPTURES A BIT OF
DELICATE FLORAL BEAUTY SURE TO LIFT THE SPIRITS OF
ANY WEARY TRAVELER.

FINISHED SIZE

Hat measures 21" (53.5 cm) in circumference and 9" (23 cm) tall. Fits a 21" (53.5 cm) to 23" (58.5 cm) head.

YARN

Worsted weight (#4 Medium). *Shown here:* Cascade 220 Superwash (100% superwash wool; 220 yd [201 m]/3½ oz [100 g]): #1960 Pacific (A), #821 Daffodil (B), #892 Space Needle (C), 1 skein each; or #842 Light Iris (A), #817 Aran (B), #847 Caribbean (C), 1 skein each.

HOOK

Size U.S. 7 (4.5 mm).

Adjust hook size if necessary to obtain correct gauge.

NOTIONS

Stitch markers; tapestry needle.

GAUGE

15 sc blo and 13 rows = 4" (10 cm).

NOTES

+ The beanie is worked from the top down.

+ The beanie body is worked in continuous rounds. Use stitch markers to mark the end of each round.

+ The beanie body is worked in single crochet through the back loop only.

+ You will carry a second strand of yarn on all hat-body rounds. On solid rounds, carry the same color of yarn.

INSTRUCTIONS

Crown

With A, make an adjustable ring.

Rnd 1: 10 sc in ring, do not join—10 sc.

Rnd 2: 2 sc in blo in each st around—20 sc.

Rnd 3: [2 sc in next st, sc in next st] 10 times—30 sc.

Rnd 4: [2 sc in next st, sc in next 2 sts] 10 times—40 sc.

Rnd 5: [2 sc in next st, sc in next 3 sts] 10 times—50 sc.

Rnd 6: [2 sc in next st, sc in next 4 sts] 10 times—60 sc.

Rnd 7: [2 sc in next st, sc in next 5 sts] 10 times—70 sc.

Rnd 8: [2 sc in next st, sc in next 6 sts] 10 times—80 sc.

Body

Rnds 1–6: Sc in each st around.

Rnds 7–19: With A and B, work Rows 1–13 of chart, working 20-st pattern rep 4 times around; fasten off B.

Rnd 20: With A, sc in each st around, change to C on last st; fasten off A.

Rnds 21–22: With C, sc in each st around; fasten off.

Finishing

Weave in ends.

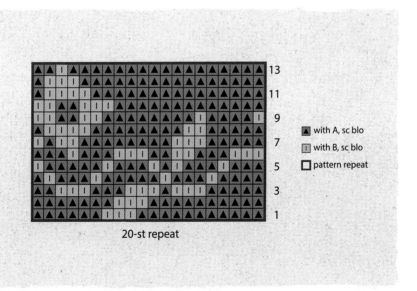

20-st repeat

▲ with A, sc blo

⊥ with B, sc blo

☐ pattern repeat

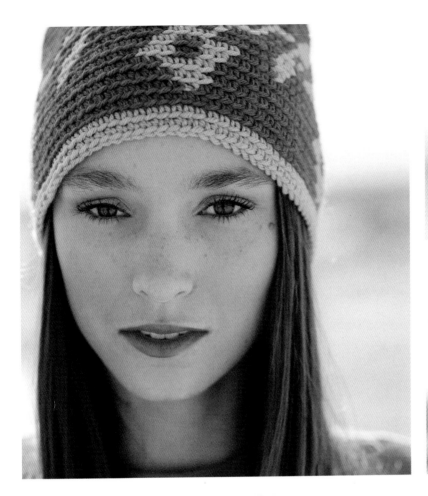

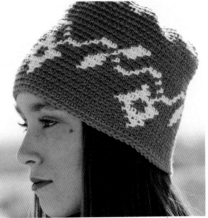
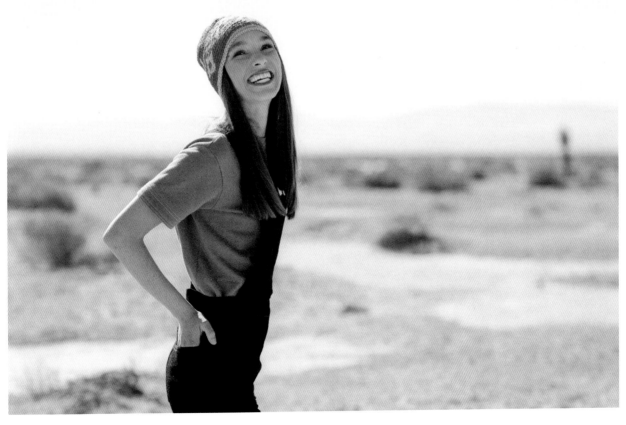

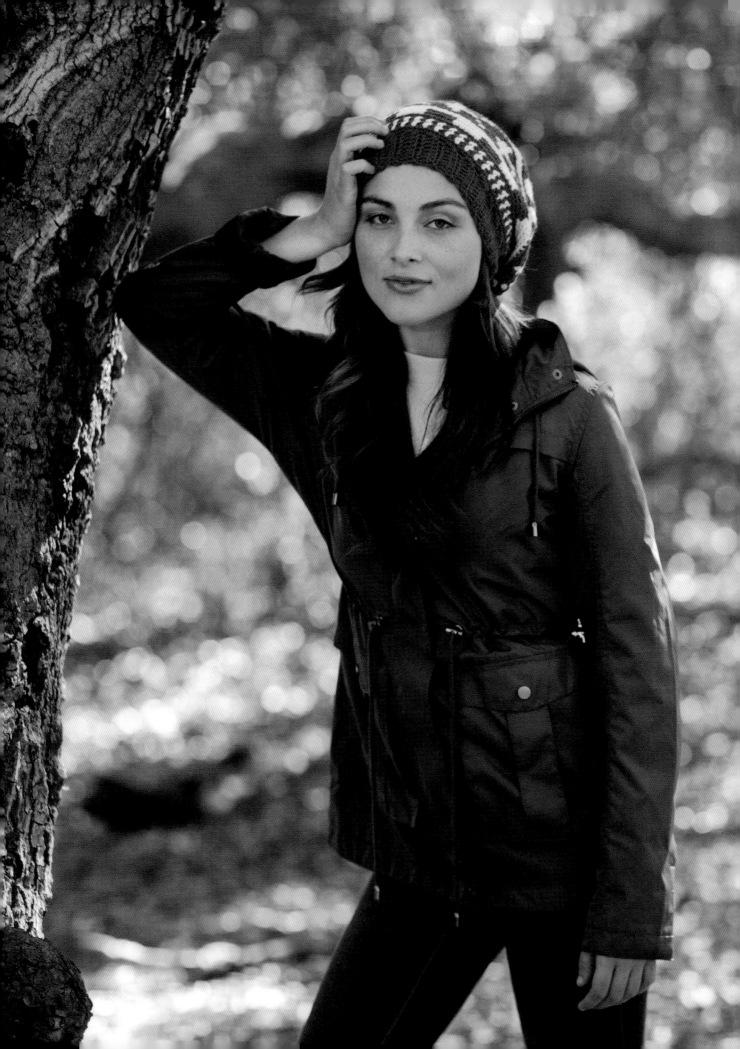

PASSENGER SLOUCH

>>>>>>>>>>>>>>>>>>>

KICK BACK AND ENJOY THE VIEW. FROM THE
MOUNTAINS TO THE CITY, THE MOTIFS ON THIS HAT ARE
REMINISCENT OF A VARIETY OF LANDSCAPES YOU MAY
ENCOUNTER ON ANY JOURNEY.

FINISHED SIZE

Hat measures 20" (51 cm) in circumference and 10½" (26.5 cm) tall. Fits a 21" (53.5 cm) to 23" (58.5 cm) head.

YARN

Worsted weight (#4 Medium). *Shown here:* Berroco Vintage (52% acrylic, 40% wool, 8% nylon; 218 yd [199 m]/3½ oz [100 g]): #5166 Sakura (A) and #5110 Fondant (B), 1 skein each; or Quince & Co. Lark (100% American Wool; 134 yd [122.5 m]/1 3/4 oz [50g]): Deft (A) and Glacier (B), 1 hank each.

HOOK

Size U.S. 7 (4.5 mm); U.S. J/10 (6 mm).

Adjust hook size if necessary to obtain correct gauge.

NOTIONS

Stitch markers; tapestry needle.

GAUGE

16 sc blo and 13 rows = 4" (10 cm) with smaller hook.

NOTES

+ The slouch is worked from the brim up. in continuous rounds. Use stitch markers to mark the end of each round.

+ The brim is worked flat, then the ends are sewn together to form a ring.

+ The body is worked in single crochet through the back loop only.

+ You will carry a second strand of yarn on all rounds. On solid rounds, carry the same color of yarn.

INSTRUCTIONS

Brim

With A and larger hook, ch 9, leaving a long tail.

Row 1: Working in blo, sc in 2nd ch from hook and each ch across, turn—8 sc.

Rows 2–50: Ch 1, sc blo in each st across, turn; do not fasten off.

Using the yarn needle and long beg tail, sew Row 1 and Row 50 together to form a ring to create the Brim.

Body

Rnd 1: With A and smaller hook, ch 1, work 2 sc in each row-end of Brim, do not join, place a st marker at the end of rnd—100 sc.

Rnds 2–20: Work Rows 1–19 of chart, working 10-st pattern rep 10 times around.

Crown

Continue with A only.

Rnd 1: [Sc in next 8 sts, sc2tog] 10 times—90 sc rem.

Rnd 2: [Sc in next 7 sts, sc2tog] 10 times—80 sc rem.

Rnd 3: [Sc in next 6 sts, sc2tog] 10 times—70 sc rem.

Rnd 4: [Sc in next 5 sts, sc2tog] 10 times—60 sc rem.

Rnd 5: [Sc in next 4 sts, sc2tog] 10 times—50 sc rem.

Rnd 6: [Sc in next 3 sts, sc2tog] 10 times—40 sc rem.

Rnd 7: [Sc in next 2 sts, sc2tog] 10 times—30 sc rem.

Rnd 8: [Sc in next st, sc2tog] 10 times—20 sc rem.

Rnd 9: Sc2tog 10 times—10 sc rem.

Break yarn and draw tail through rem sts. Pull tight to gather sts and fasten off on wrong side.

Finishing

Weave in ends.

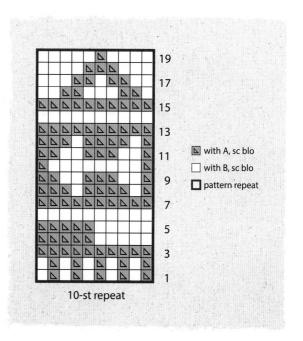

10-st repeat

with A, sc blo
with B, sc blo
pattern repeat

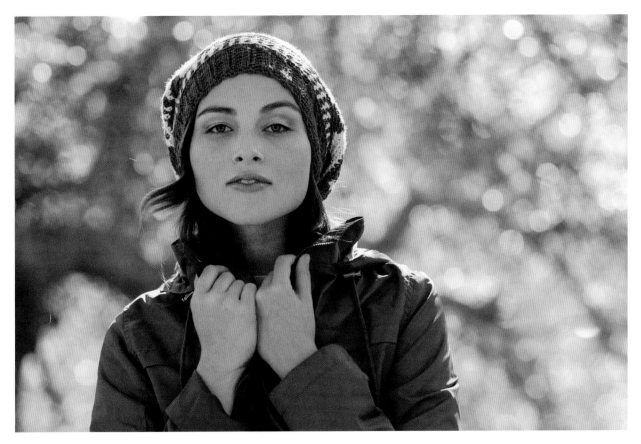

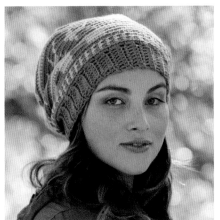

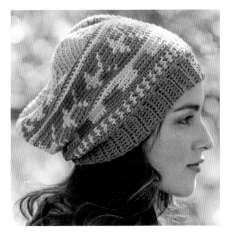

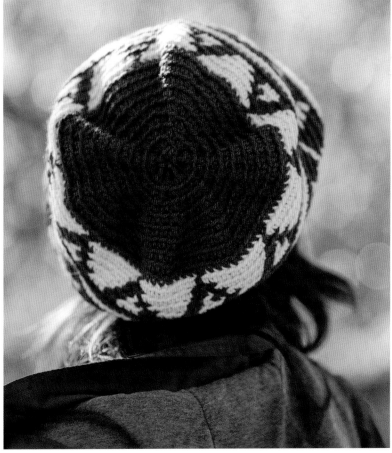

BE PREPARED

BAGS & THROWS

>>>>>>>>>>>>>>>>>>>>>

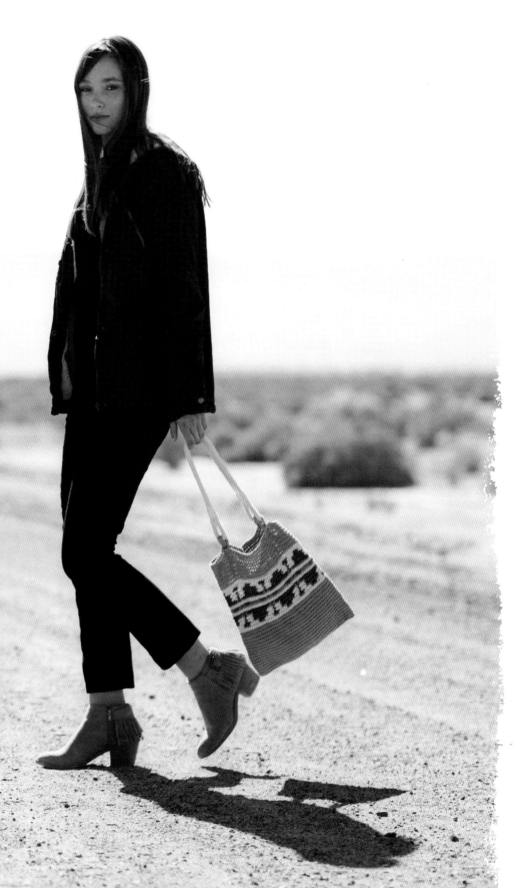

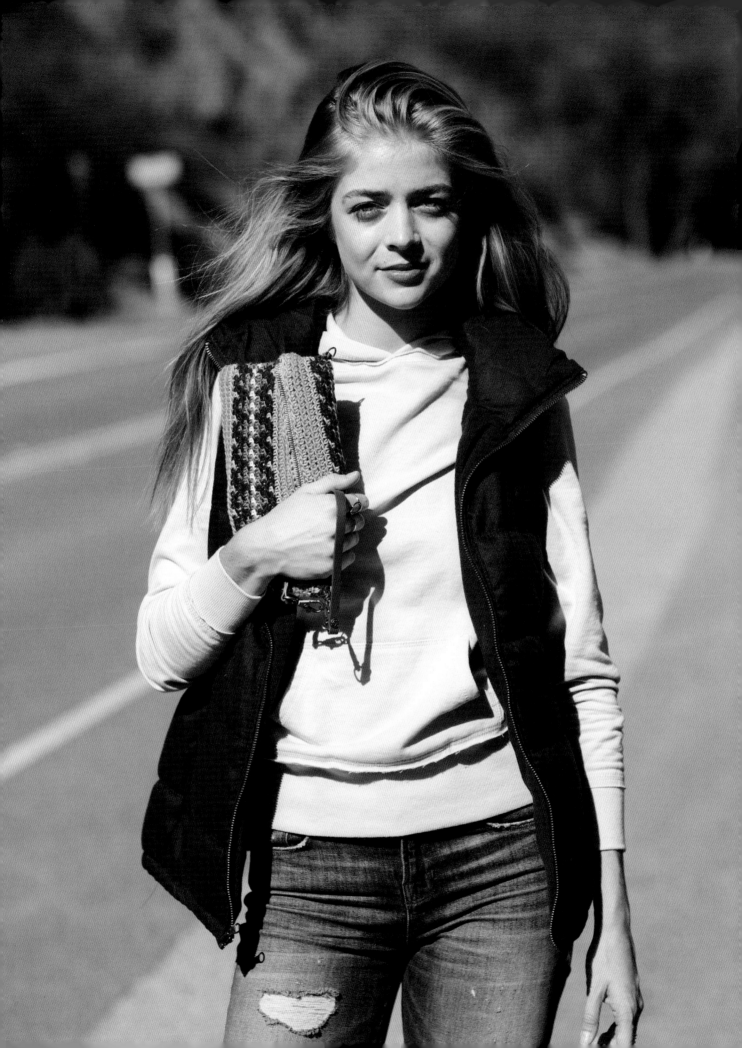

QUICK-STOP CLUTCH

>>>>>>>>>>>>>>>>>>>>

WHEN YOU'RE ON THE GO, SOMETIMES A CLUTCH IS ALL YOU
NEED TO CARRY THE ESSENTIALS—WALLET, KEYS, LIP-GLOSS.
STITCH UP THIS ONE IN A BOLD COLOR PALETTE FOR AN EYE-
CATCHING ADDITION TO ANY OUTFIT.

FINISHED SIZE

Clutch measures 9" (23 cm) wide
and 7¼" (18.5 cm) tall.

YARN

Worsted weight (#4 Medium).
Shown here: Lion Brand 24/7
Cotton (100% mercerized cotton;
186 yd [170 m]/3½ oz [100 g]):
#158 Goldenrod (A), #102 Aqua
(B), #144 Magenta (C), #126
Cafe Au Lait (D), #100 White (E),
1 skein each.

HOOK

Size G/6 (4 mm).

*Adjust hook size if necessary to
obtain correct gauge.*

NOTIONS

Stitch markers; tapestry needle;
9" (23 cm) zipper; purse handle
(shown here: 13.6" (34.5 cm) faux
leather handle with buckles); 1
piece of cotton fabric 18" × 21"
(45.5 × 53.5 cm); 2 magnetic
clasps; sewing needle and thread.

GAUGE

18 sc blo and 14 rows = 4" (10 cm)

NOTES

+ The clutch is worked in
continuous rounds; use stitch
markers to mark the end of each
round.

+ The clutch is worked in sc
through the back loop only.

+ You will carry a second strand of
yarn on all rounds; on solid rounds,
carry the same color of yarn.

+ Start each row with a
slipknot on your hook.

+ To adjust the length of your
scarf, adjust the length of your
beginning chain, adding or
subtracting multiples of 21.

+ Use stitch markers between
the chart repeats.

INSTRUCTIONS

With color A, ch 41.

Rnd 1: Sc in 2nd ch from hook and in each ch across, rotate piece to work along opposite edge of the foundation ch, sc in each ch across—80 sc.

Rnd 2: Sc in each st around.

Rnds 3–11: Work Rows 1–9 of chart, working 4-st pattern rep 20 times around.

Rnds 12–13: With A, sc in each st around.

Rnds 14–24: Rep Rnds 3–13.

Rnd 25: With B, sc in each st around; fasten off.

Finishing

Weave in ends.

Fold the fabric piece in half, RS facing in, and trim it to fit the clutch. Using a needle and thread, sew the sides closed. Slide the fabric inside the clutch and hand sew the top edges to secure it to the clutch.

Open and close zipper a few times to make sure it's in working order. Unzip the zipper and pin it in place to the inside of the top edge of clutch. With a sewing needle and matching thread, sew the zipper to the piece.

Fold the clutch at desired height. Using the tapestry needle and matching yarn, attach the purse handle by sewing the D-rings to one side edge at the fold or one D-ring at each side edge at the fold.

Sew the magnetic clasps to the inside of the flap and the purse body to hold the flap in place.

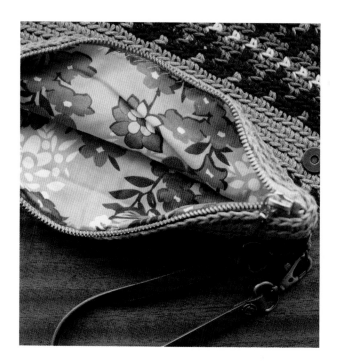

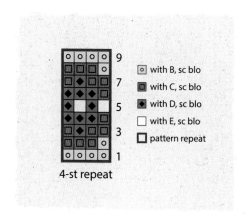

with B, sc blo
with C, sc blo
with D, sc blo
with E, sc blo
pattern repeat

4-st repeat

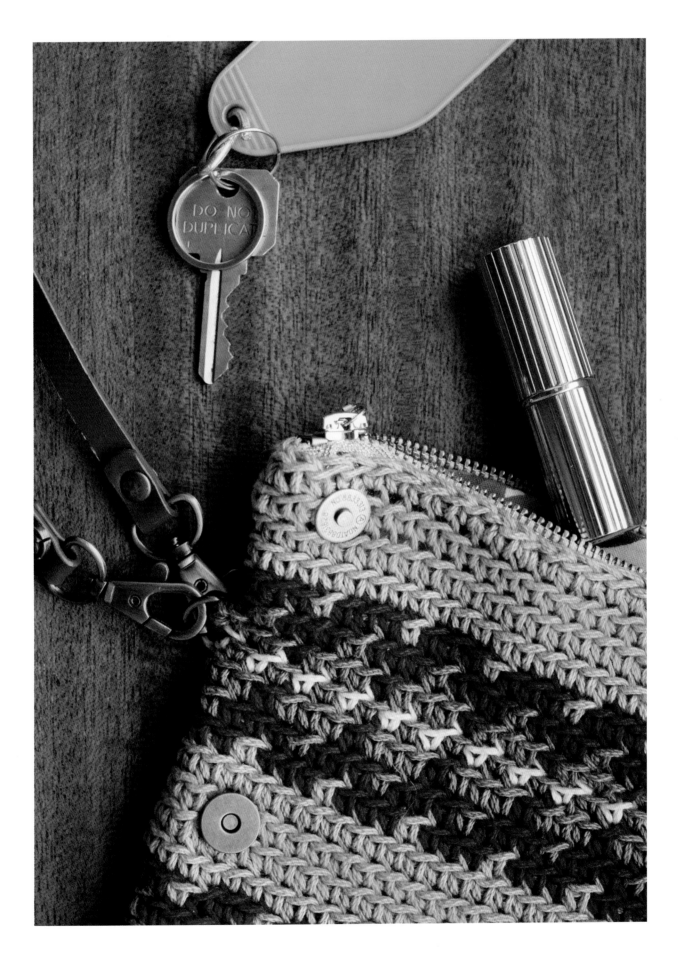

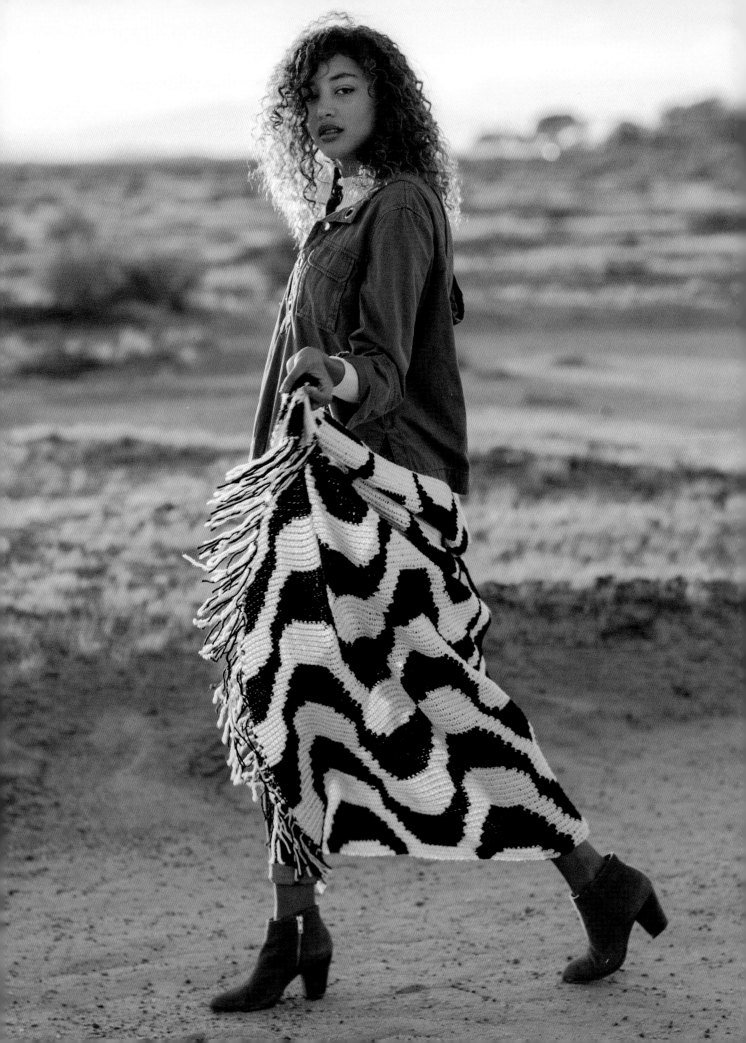

SWITCHBACK THROW

>>>>>>>>>>>>>>>>>>>>>

THE MOTIF ON THIS BLANKET ECHOES THE CURVY PATH THAT
MAKES TRAVELING UPHILL SO MUCH EASIER. THE CRISP
BLACK-AND-WHITE CONTRAST LOOKS EQUALLY GREAT SPREAD
OUT FOR A ROADSIDE PICNIC OR SNUGGLED IN YOUR LAP.

FINISHED SIZE

Blanket measures 55½" (141 cm) wide (excluding fringe) and 42¾" (108.5 cm) tall.

YARN

Aran weight (#4 Medium). *Shown here:* Lion Brand Vanna's Choice (100% acrylic; 170 yd [156 m]/3½ oz [100 g]): #100 White (A), #153 Black (B), 6 skeins each.

HOOK

Size U.S. I/9 (5.5 mm).

Adjust hook size if necessary to obtain correct gauge.

NOTIONS

Stitch markers.

GAUGE

13 sc blo and 9 rows = 4" (10 cm).

NOTES

+ Leave a 9" (23 cm) tail at the beginning and end of each row in each color. These tails will become the fringe.

+ Always crochet on the right side of your work, from right to left.

+ Start each row with a slipknot on your hook.

+ To adjust the width of your blanket, adjust the length of your beginning chain, adding or subtracting multiples of 36. Work additional chart repeats to add length.

+ Use stitch markers between the chart repeats.

INSTRUCTIONS

With color A, ch 181.

Row 1: Working in back loop of ch, work Row 1 of chart, placing 1st sc in 2nd ch from hook and then in each ch across, working 36-st pattern rep 5 times across—180 sc.

Rows 2-96: Work Rows 2–32 of chart, then work Rows 1–32 of chart 2 more times.

Finishing

Tie the ends of 2 rows together to create fringe.

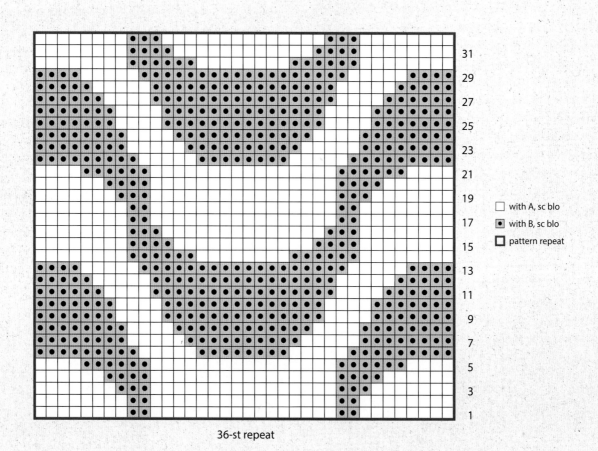

36-st repeat

☐ with A, sc blo
• with B, sc blo
☐ pattern repeat

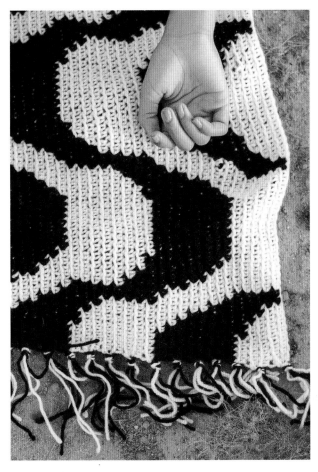

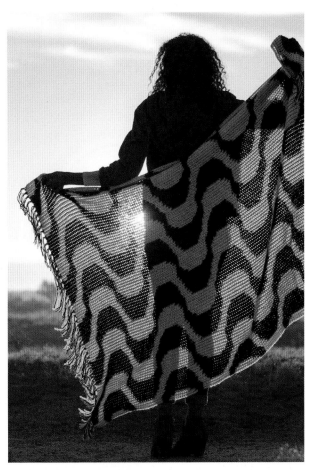

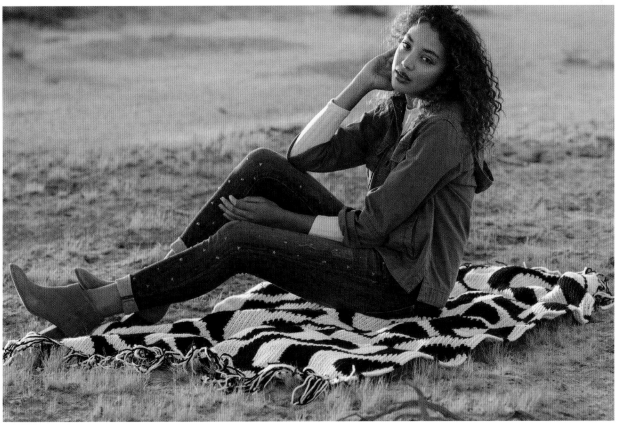

PROVISIONS TOTE

>>>>>>>>>>>>>>>>>>>>

WHEREVER YOU GO, A TRUSTY TOTE BAG THAT GOES WITH
EVERYTHING IS A TRAVEL ESSENTIAL. THIS ONE CAN HOLD
IT ALL, FROM YOUR WALLET AND KEYS TO A SNACK AND THAT
JUST-IN-CASE SCARF OR MITTENS.

FINISHED SIZE

Bag measures 11" (28 cm) wide
and 11¼" (28.5 cm) tall.

YARN

Worsted weight (#4 Medium).
Shown here: Lion Brand 24/7
Cotton (100% mercerized cotton;
186 yd [170 m]/3½ oz [100 g]):
#150 Charcoal (A), 2 balls; #122
Taupe (B), 1 ball.

HOOK

Size U.S. 7 (4.5 mm).

*Adjust hook size if necessary
to obtain correct gauge.*

NOTIONS

Stitch markers; tapestry needle;
purse straps (*shown here:* Purse
n-alize it! Vinyl Braid with Round
Rings Purse Handle).

GAUGE

18 sc blo and 14 rows = 4" (10 cm).

NOTES

+ The bag is worked in continuous
rounds. Use stitch markers to mark
the end of each round.

+ The bag is worked in single
crochet through the back loop only.

+ You will carry a second strand of
yarn on all rounds. On solid rounds,
carry the same color of yarn.

INSTRUCTIONS

Bag

With A, ch 49.

Rnd 1: Sc in 2nd ch from hook and in each ch across, rotate piece to work along opposite edge of the foundation ch, work sc in each ch across; do not join—96 sc.

Rnd 2: 2 sc in 1st st, sc in next 46 sts, 2 sc in next 2 sts, sc in next 47 sts—99 sts.

Rnds 3–9: Sc blo in each st around.

Rnds 10–11: With B, sc blo around.

Rnds 12–28: Work Rows 1–17 of chart, working 11-st pattern rep 9 times around.

Rnds 29–30: With B, sc blo around.

Rnds 31–39: With A, sc blo around; fasten off.

Handle Tab (Make 4)

With A, ch 4.

Row 1: Sc in 2nd ch from hook and in last 2 sts, turn—3 sc.

Rows 2–7: Ch 1, sc in each st across; fasten off, leave a long tail for sewing.

Finishing

Lay bag flat and measure 2½" (6.5 cm) from each side fold for handle tab placement. Insert a handle tab in a handle ring and sew on inside of bag into place. Rep for remaining 3 handle rings. Weave in ends.

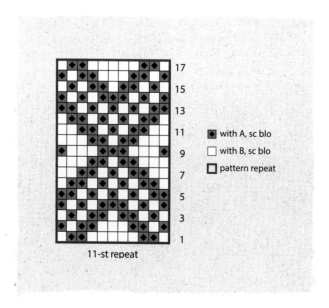

11-st repeat

■ with A, sc blo
□ with B, sc blo
▢ pattern repeat

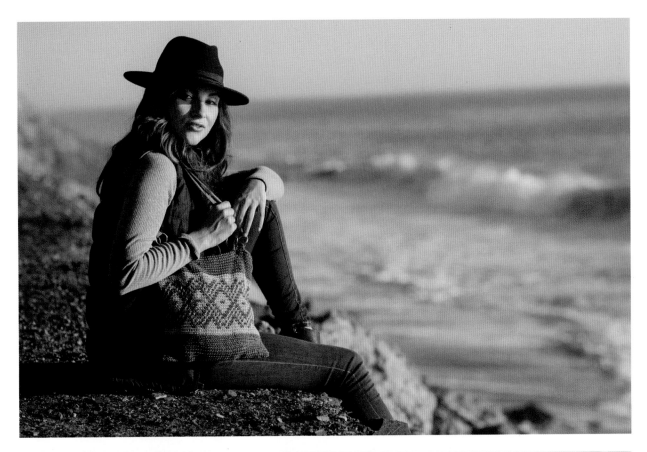

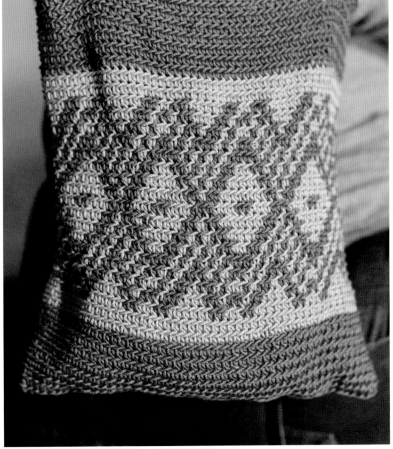

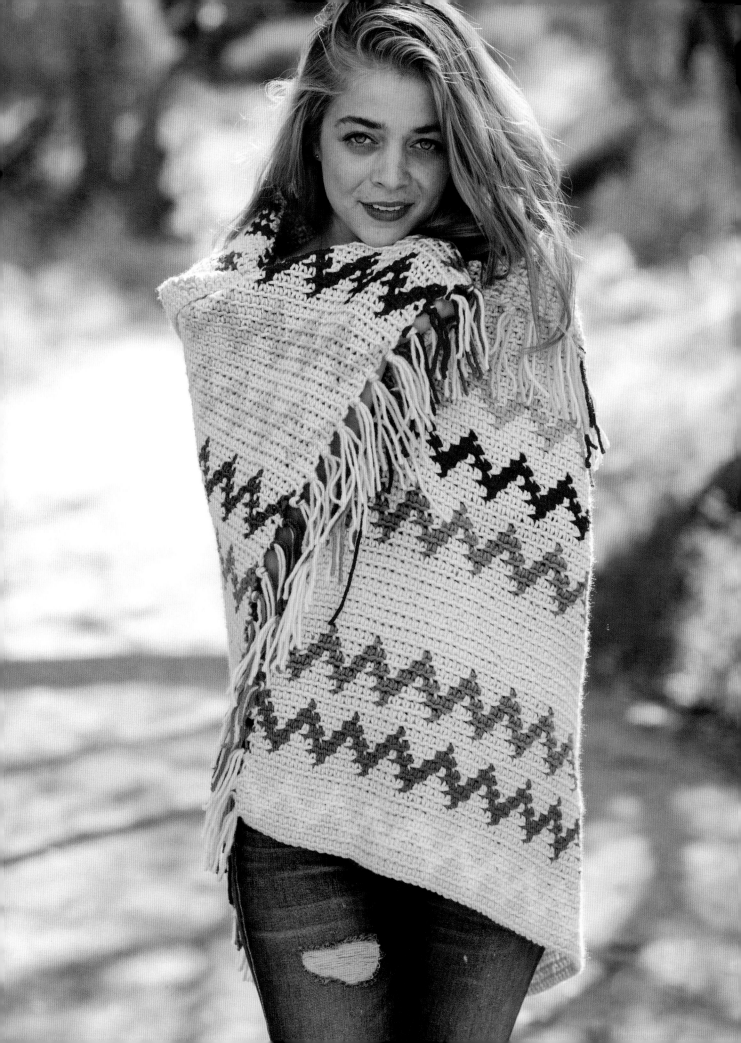

DISTANT MOUNTAINS THROW

>>>>>>>>>>>>>>>>>>>>

FROM LIGHT TO DARK, MOUNTAINS ON THE HORIZON CAN
TAKE ON PRACTICALLY ANY COLOR. THIS COZY THROW
CELEBRATES THEM ALL AND PROVIDES A COLORFUL LAYER TO
CUDDLE UP UNDER IF A CHILL SETS IN.

FINISHED SIZE

Blanket measures 35" (89 cm)
wide (excluding fringe) and 41½"
(105.5 cm) long.

YARN

Aran weight (#4 Medium).
Shown here: Big Twist Yarns
Premium Solids (100% acrylic;
137 yd [125 m]/3½ oz [100 g]):
#2002 Ivory (MC), 4 skeins;
#2014 Turmeric (A), #2015 Royal
(B), #2024 Scarlet (C), #2012
Sprout (D), #2018 Salmon (E),
#XX Passion Flower (F), #2013
Yam (G), #2017 Turquoise (H),
#02011 Moss (I), #2019 Sangria
(J), #02026 Peacock (K), #02028
Maize (L), #2032 Kale (M),
#2029 Persimmon (N), #02020
Almost Aqua (O), 1 skein each.

HOOK

Size U.S. 7 (4.5 mm).

*Adjust hook size if necessary
to obtain correct gauge.*

NOTIONS

Stitch markers.

GAUGE

13 sc blo and 9 rows = 4" (10 cm).

NOTES

+ You will always start with the
main color (MC) and carry the
contrast color (CC).

+ Leave a 9" (23 cm) tail at the
beginning and end of each row in
each color. These tails will become
the fringe.

+ Always crochet on the
right side of your work, from
right to left.

+ Start each row with a
slipknot on your hook.

+ To adjust the width of your
blanket, adjust the length of
your beginning chain, adding or
subtracting multiples of 6. Work
additional chart repeats to add
length.

+ Use stitch markers between
the chart repeats.

INSTRUCTIONS

With MC, ch 104 (this will give you 17 pattern repeats).

Row 1: With MC, working in back loop of ch, sc in 2nd ch from hook and each ch across—103 sc.

Rows 2–7: With MC and A as CC, work Rows 1–6 of chart, working 6-st pattern rep 17 times across, then work last st of chart.

Rep Rows 2–7 fourteen more times with colors B–O as CC; fasten off.

Finishing

Tie the ends of 3 rows together to create fringe.

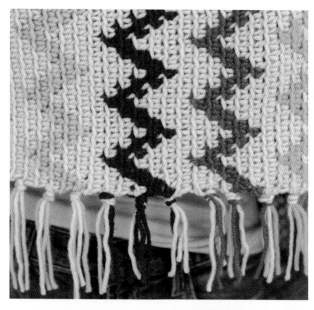

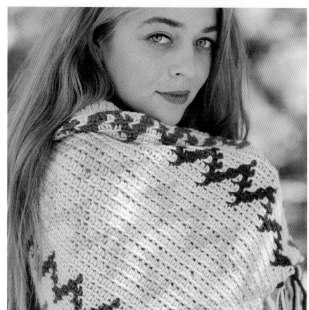

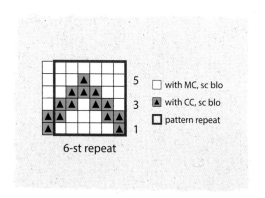

□ with MC, sc blo
▲ with CC, sc blo
▢ pattern repeat

6-st repeat

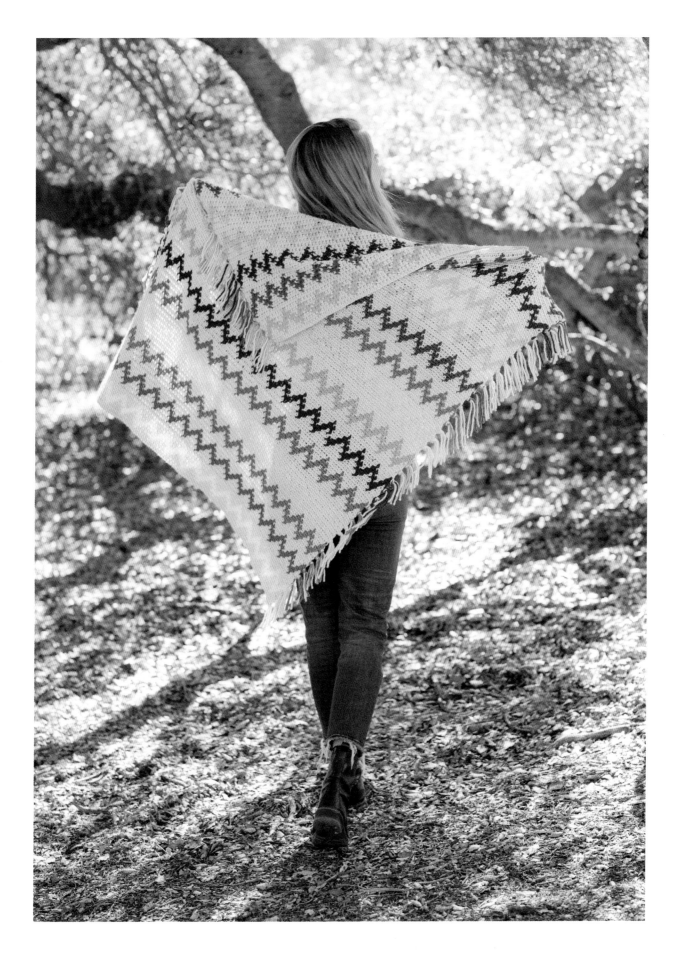

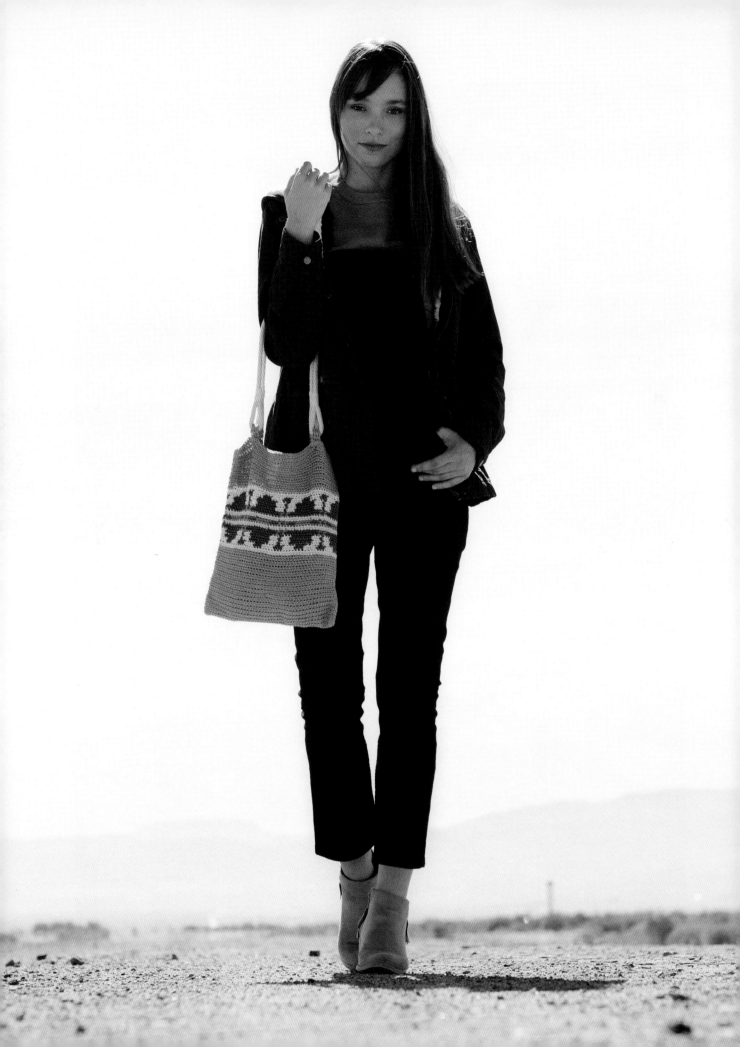

EN ROUTE BAG

>>>>>>>>>>>>>>>>>>>>

WHILE EXPLORING NATURAL AND URBAN ENVIRONMENTS ALIKE, THIS COLORFUL BAG IS THE PERFECT SIZE FOR ANY ADVENTURE. STURDY COTTON YARN AND ROPE HANDLES MAKE A RELIABLE TOTE FOR SOUVENIRS AND SNACKS.

FINISHED SIZE

Bag measures 11" (28 cm) wide and 12" (30.5 cm) tall (excluding handles).

YARN

Worsted weight (#4 Medium). *Shown here*: Lion Brand 24/7 Cotton (100% mercerized cotton; 186 yd [170 m]/3½ oz [100 g]): #122 Taupe (A), 2 skeins; #098 Ecru (B), #142 Rose (C), #178 Jade (D), #157 Lemon (E), #102 Aqua (F), #143 Lilac (G), 1 skein each.

HOOK

Size U.S. G/6 (4 mm).

Adjust hook size if necessary to obtain correct gauge.

NOTIONS

Stitch markers; tapestry needle; two 21½" (54.5 cm) woven cotton handles.

GAUGE

17 sc blo and 13 rows = 4" (10 cm).

NOTES

+ The bag is worked in continuous rounds. Use stitch markers to mark the end of each round.

+ The bag is worked in single crochet through the back loop only.

+ You will carry a second strand of yarn on all rounds. On solid rounds, carry the same color of yarn.

INSTRUCTIONS

With A, ch 50.

Rnd 1: Sc blo in 2nd ch from hook and each ch across, rotate piece to work along opposite edge of the foundation ch, sc in each ch across—98 sc.

Rnds 2–16: Sc blo in each st around.

Rnds 17–29: Work Rows 1–13 of chart, working 14-st pattern rep 7 times around.

Rnds 30–38: With A, sc blo in each st around; fasten off.

Handle Tab (Make 4)

With A, ch 4.

Row 1: Sc in 2nd ch from hook and each ch across, turn—3 sc.

Rows 2–8: Ch 1, sc in each st across, turn.

Fasten off, leaving a long tail for sewing.

Finishing

Lay bag flat and measure 2" (5 cm) from each side fold for handle tab placement. Insert a handle tab in a handle loop and sew on inside of bag into place. Rep for remaining 3 handle tabs. Weave in ends.

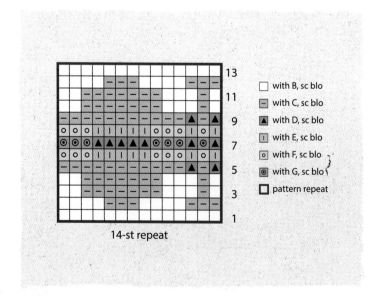

14-st repeat

- □ with B, sc blo
- ⊟ with C, sc blo
- ▲ with D, sc blo
- Ⅰ with E, sc blo
- ○ with F, sc blo
- ◎ with G, sc blo
- ☐ pattern repeat

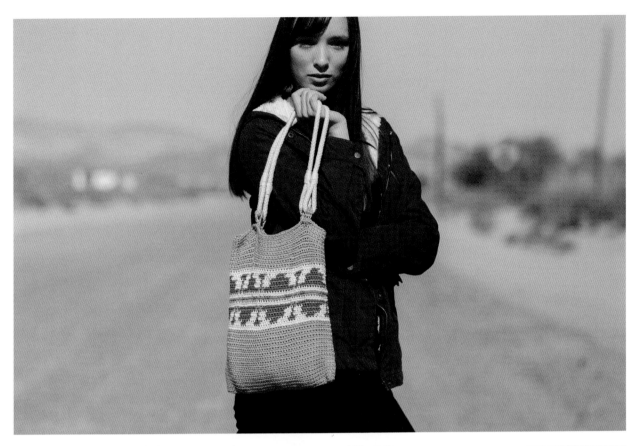

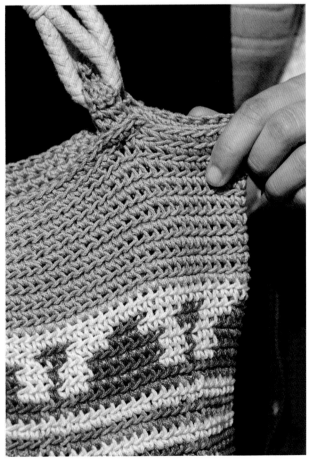

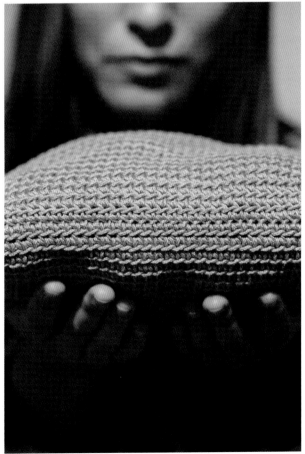

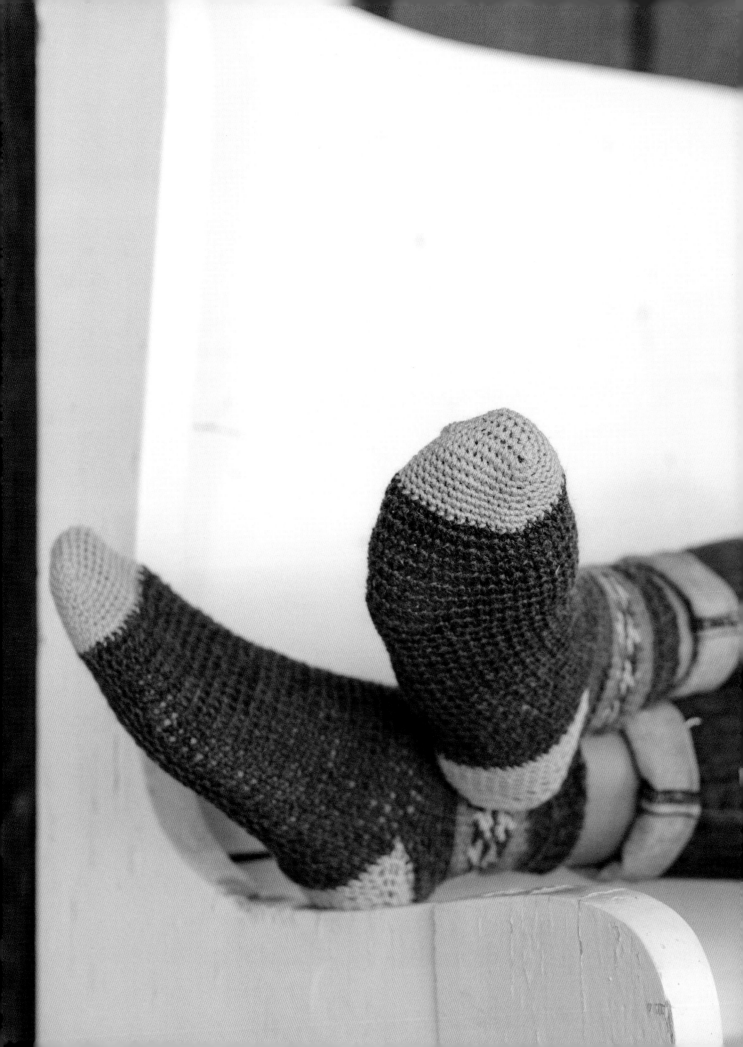

TAKE A BREAK

SOCKS & MITTENS

>>>>>>>>>>>>>>>>>>>

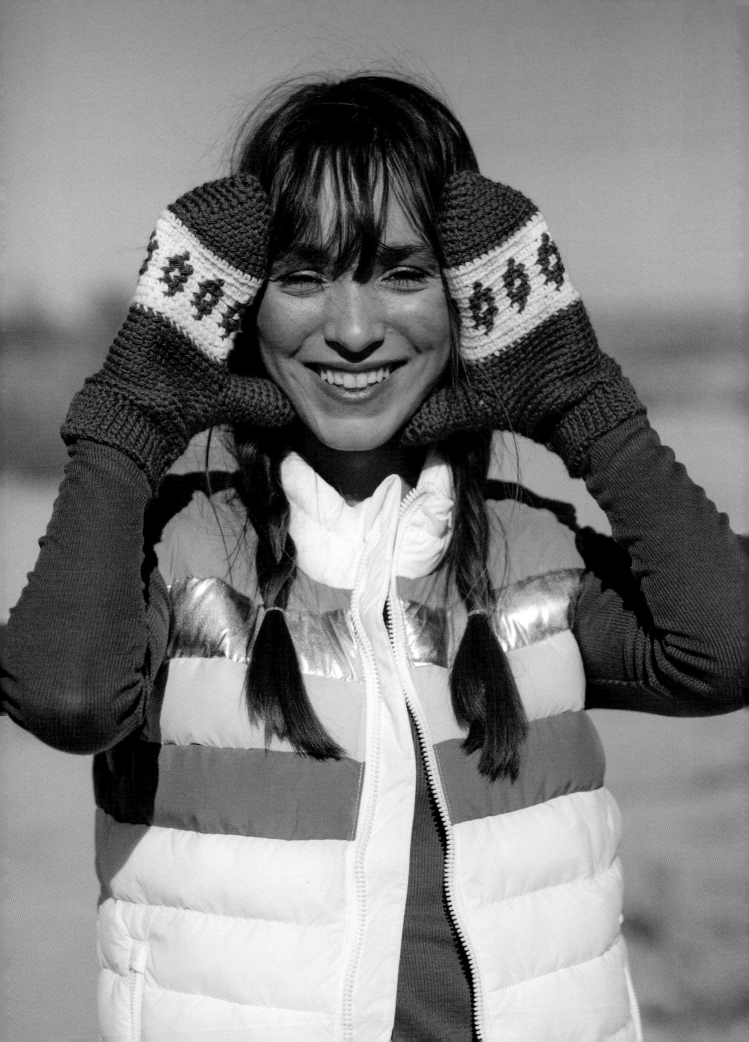

NORTHWAY MITTENS

>>>>>>>>>>>>>>>>>>>>>

WINTER CAN BE A BEAUTIFUL TIME TO HIT THE ROAD,
TOO, JUST AS LONG AS YOU ARE PREPARED FOR
THE COLD. THESE MITTENS WILL DO THE TRICK TO KEEP
YOUR HANDS WARM IN STYLE.

FINISHED SIZE

Mittens measures 8" (20.5 cm) around palm; 8.5" (21.5 cm) from fingertip to wrist. One size fits most.

YARN

Worsted weight (#4 Medium). *Shown here:* Berroco Vintage (52% acrylic, 40% wool, 8% nylon; 218 yd [199 m]/3½ oz [100 g]): #5130 Taupe (A), #5113 Misty (B), #5101 Mochi (C), 1 skein each; or #5124 Kiwi (A), #5155 Delphinium (B), #5100 Snow Day (C), 1 skein each.

HOOK

Size U.S. G/6 (4 mm).

Adjust hook size if necessary to obtain correct gauge.

NOTIONS

Stitch markers; tapestry needle.

GAUGE

14 sc blo and 12 rows = 4" (10 cm).

NOTES

+ The mittens are worked from the top down.

+ The mittens are worked in continuous rounds. Use stitch markers to mark the end of each round.

+ Cuff is worked flat.

+ Work in single crochet through the back loop only.

+ You will only carry a second strand of yarn on Rounds 10–18.

INSTRUCTIONS

With A, make an adjustable ring.

Rnd 1: 5 sc in ring, do not join—5 sc.

Rnd 2: 2 sc in each st around—10 sc.

Rnd 3: [2 sc in next st, sc in next st] 5 times—15 sc.

Rnd 4: [2 sc in next st, sc in next 2 sts] 5 times—20 sc.

Rnd 5: [2 sc in next st, sc in next 3 sts] 5 times—25 sc.

Rnd 6: [2 sc in next st, sc in next 4 sts] 5 times—30 sc.

Rnd 7: [2 sc in next st, sc in next 5 sts] 5 times—35 sc.

Rnds 8–9: Sc in each st around.

Rnds 10–18: Work Rows 1–9 of chart, working 5-st pattern rep 7 times around.

Continue with A only.

Rnds 19–21: With A, sc in each st around.

Rnd 22: Ch 7, skip next 7 sts (thumb hole made), sc in last 28 sts.

Rnd 23: 7 sc in ch-7 sp, sc in last 28 sts—35 sc.

Rnds 24–31: Sc in each st around, sl st in 1st sc to join; do not fasten off.

Cuff

Ch 8, turn.

Row 1: (WS) Sl st in 2nd ch from hook and in last 6 ch across, sl st in next mitten row-end, turn.

Row 2: Sl st in each sl st across, turn—7 sts.

Row 3: Ch 1, sl st in each sl st across, sl st in next mitten row-end, turn.

Rep Rows 2–3 around mitten circumference.

Using the yarn needle, sew Cuff ends together.

Thumb

With the Cuff at the bottom, join A with sl st in st at the right corner of Thumb hole.

Rnd 1: 2 sc in the same st as join, sc in next 6 sts of bottom of Thumb hole, rotate mitten, 2 sc in the 1st st of upper Thumb hole, sc in each of rem 6 sts of Thumb hole—16 sc.

Rnd 2: Sc in each st around.

Rep Rnd 2 until Thumb measures 2" (5 cm).

Rnd 3: [Sc in next 2 sts, sc2tog] 4 times—12 sc rem.

Rnd 4: [Sc in next st, sc2tog] 4 times—8 sc rem.

Rnd 5: Sc2tog 4 times—4 sc rem.

Break yarn and draw tail through rem sts. Pull tight to gather sts and fasten off on wrong side.

Repeat instructions to make second mitten.

Finishing

Weave in ends.

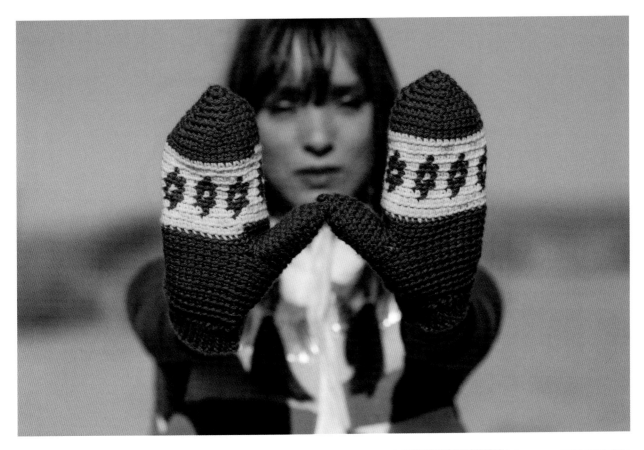

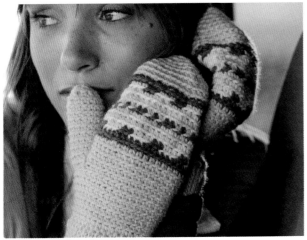

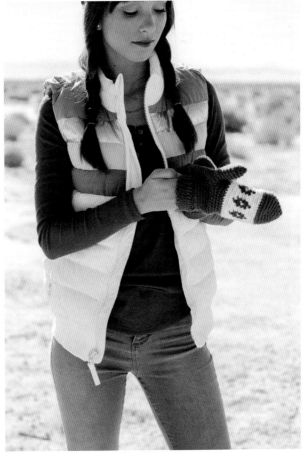

⊙	⊙	⊙	⊙	⊙		9
⊙				⊙		
		◆				7
	◆	◆	◆			
⊙	◆		◆	⊙		5
	◆	◆	◆			
		◆				3
⊙				⊙		
⊙	⊙	⊙	⊙	⊙		1

◆ with A, sc blo
⊙ with B, sc blo
☐ with C, sc blo
☐ pattern repeat

5-st repeat

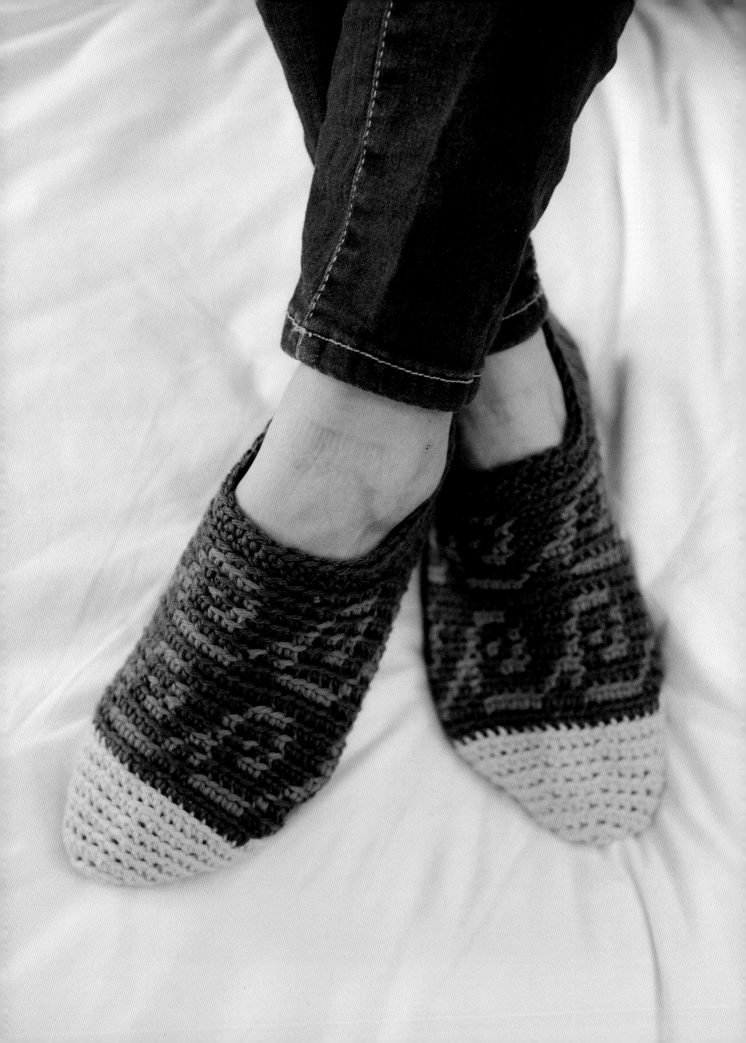

SEASIDE SLIPPERS

>>>>>>>>>>>>>>>>>>>>>

THE CURL OF A WAVE LOOKS JUST AS GOOD ON A VISIT TO
THE SEA AS IT DOES ON YOUR FEET. THESE SLIPPERS HAVE
STRAIGHTFORWARD CONSTRUCTION AND WORK UP QUICKLY
IN A WORSTED-WEIGHT YARN, MAKING THEM A WONDERFUL
INTRODUCTION TO TAPESTRY-CROCHETED SOCKS.

FINISHED SIZE

Slippers measure 8½" (21.5 cm) in circumference and 9" (23 cm) long (length is adjustable). Fits average-sized adult woman.

YARN

Aran weight (#4 Medium). *Shown here:* Knit Picks Comfy Worsted (75% pima cotton, 25% acrylic; 109 yd [100 m]/1¾ oz [50 g]): #26979 Semolina (A), #25312 Hawk (B), #25768 Marina (C), 1 ball each; or #24800 Whisker (A), #24423 Peony (B), #25771 Carrot (C), 1 ball each.

HOOK

Size U.S. G/6 (4.00 mm).

Adjust hook size if necessary to obtain correct gauge.

NOTIONS

Stitch markers; tapestry needle.

GAUGE

11 sc blo and 8 rows = 4" (10 cm).

NOTES

◆ Always crochet on the right side of your work, from right to left.

◆ Slippers are worked in a continuous round. Use stitch markers to mark the end of each round.

◆ When working in the round, crochet through back loop only. The final flat rows are worked through both loops as a standard single crochet.

◆ Work over the second strand of yarn in all rounds. On solid rounds, use the same color yarn to crochet over.

◆ Don't pull tight on the rounds or your slipper will be too tight and uncomfortable.

INSTRUCTIONS

With A, make an adjustable ring.

Toe

Rnd 1: 8 sc in ring, do not join—8 sc.

Rnd 2: 2 sc blo in each st around—16 sc.

Rnd 3: [2 sc in next st, sc in next st] 8 times—24 sc.

Rnd 4: Sc in each st around.

Rnd 5: [2 sc in next st, sc in next 2 sts] 8 times—32 sc.

Rnd 6: Sc in each st around.

Rnd 7: [2 sc in next st, sc in next 3 sts] 8 times—40 sc.

Rnd 8: Sc in each st around, change to B on last st; fasten off A.

Rnd 9: With B, sc around.

Foot

Rnds 10-23: With B and C, work Rows 1–7 of chart 2 times, working 8-st pattern rep 5 times around; fasten off C.

Heel

Continue working in rows with B only.

Row 1: Sc in next 5 sts, turn.

Rows 2-14: Ch 1, sc in next 26 sts across, turn.

Work more or fewer rows as needed to make the slippers longer or shorter.

Fasten off, leaving a long tail for sewing.

Repeat instructions to make second slipper.

Finishing

Fold Heel in half and, using the yarn needle, sew Heel seam closed.

Sc around the slipper opening twice. Weave in ends.

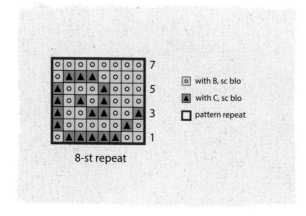

7

5

3

1

⊡ with B, sc blo

▲ with C, sc blo

☐ pattern repeat

8-st repeat

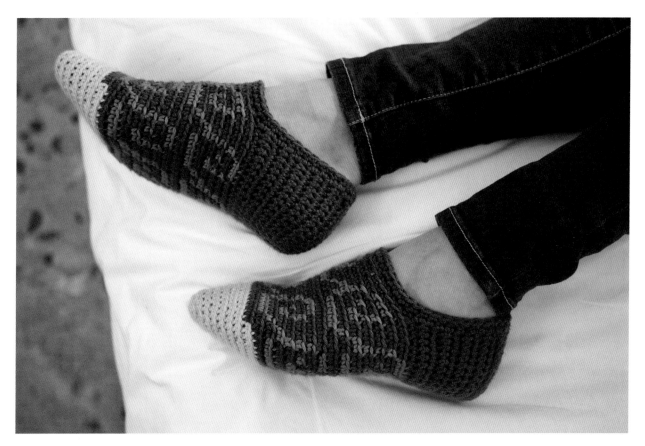

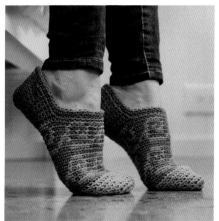

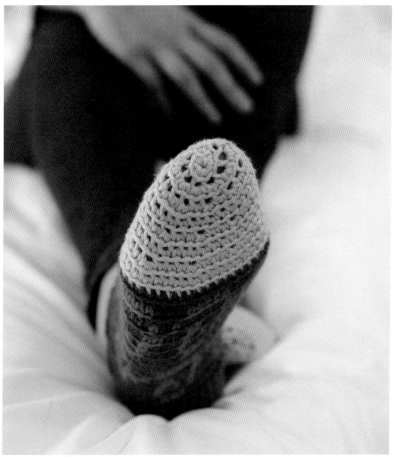

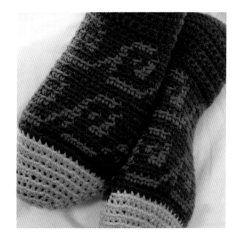

SCENIC OVERLOOK MITTS

>>>>>>>>>>>>>>>>>>>

FINGERLESS MITTS ARE THE PERFECT PROJECT TO TRY YOUR
HAND AT GETTING THE FAIR ISLE LOOK IN CROCHET. THESE
STITCH UP QUICKLY AND ARE THE PERFECT ACCESSORY FOR
DRIVING OR SNAPPING PHOTOS.

FINISHED SIZE

Mitts measure 7" (18 cm) in
circumference and 7½" (19 cm)
long. Fits average-sized adult
woman.

YARN

Worsted weight (#4 Medium).
Shown here: Knit Picks Comfy
Worsted (75% pima cotton, 25%
acrylic; 109 yd [100 m]/1¾ oz
[50 g]): #24800 Whisker (A),
#25313 Fairy Tale (B), #25771
Carrot (C), and #25768 Marina
(D), 1 skein each.

HOOK

Size U.S. G/6 (4 mm); U.S. J/10
(6 mm).

*Adjust hook size if necessary
to obtain correct gauge.*

NOTIONS

Stitch markers; tapestry needle.

GAUGE

8 sc blo and 7 rows = 2" (5 cm)
with smaller hook.

NOTES

+ The mitts are worked from
the cuff up.

+ The cuff is worked flat, then
the ends are sewn together.

+ The mitt body is worked in
continuous rounds. Use stitch
markers to mark the end of each
round.

+ The mitt body is worked in single
crochet through the back loop only.

+ You will carry a second strand of
yarn on all mitt-body rounds. On
solid rounds, carry the same color
of yarn.

STITCH GUIDE
Reverse Single Crochet

Working from left to right, insert hook in next stitch from front to back, yarn over and draw through both loops on hook (starting single crochet), *insert hook in next stitch to right **(Figure 1)**, yarn over and pull up loop, yarn over **(Figure 2)** and draw through both loops on hook **(Figure 3)**. Repeat from *.

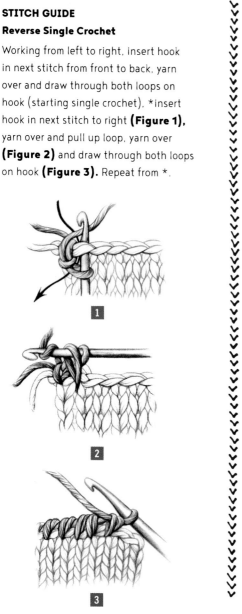

INSTRUCTIONS

Cuff

With A and larger hook, ch 11.

Row 1: Hdc in 3rd ch from hook and in each ch across, turn—9 hdc.

Rows 2–14: Ch 2, hdc blo across, turn; do not fasten off.

Sl st Row 1 and Row 14 together to form a ring for the Cuff.

Body

Rnd 1: With A and smaller hook, ch 1, 2 sc in each row-end around—28 sc.

Rnd 2: Sc blo in each st around.

Rnds 3–10: Work Rows 1–8 of chart, working 7-st pattern rep 4 times around.

Rnds 11–14: With A, sc blo in each st around.

(continued on page 108)

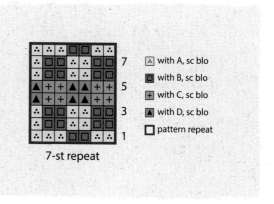

7-st repeat

with A, sc blo
with B, sc blo
with C, sc blo
with D, sc blo
pattern repeat

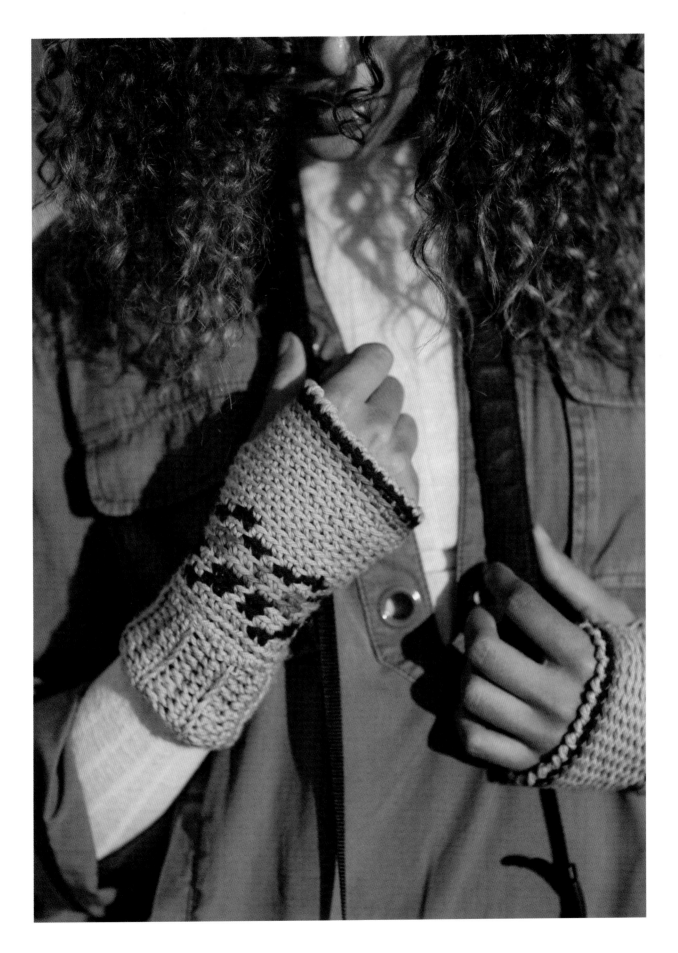

Left Mitt

Rnd 15: Sc blo in next 4 sts, ch 4, skip next 4 sts (thumb hole made), sc blo in rem 20 sts.

Right Mitt

Rnd 15: Sc blo in next 24 sts, ch 4, skip next 4 sts (thumb hole made).

Both Mitts

Rnd 16: Sc blo in each st around and work 4 sc in ch-4 space—28 sc.

Rnd 17: Sc blo in each st around, changing to C on the last st.

Rnd 18: With C, sc blo in each st around, changing to D on the last st.

Rnd 19: With D, sc blo in each st around, changing to B on the last st.

Rnd 20: With B, sc blo in each st around, changing to A on the last st.

Rnd 21: With A, rev sc around, sl st in 1st rev sc to join; fasten off.

Finishing

Weave in ends.

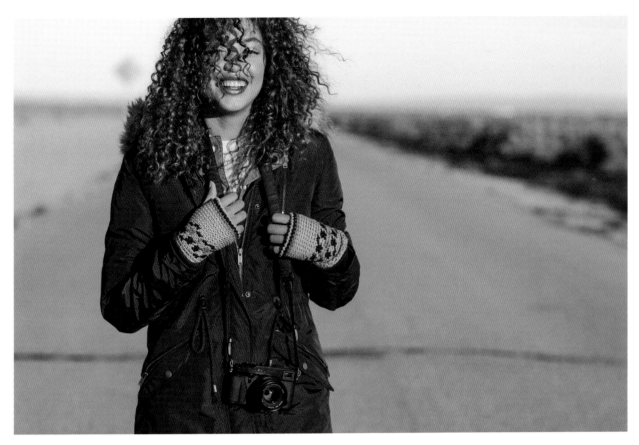

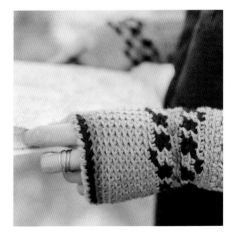

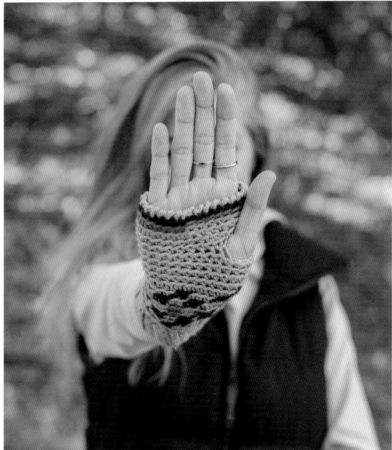

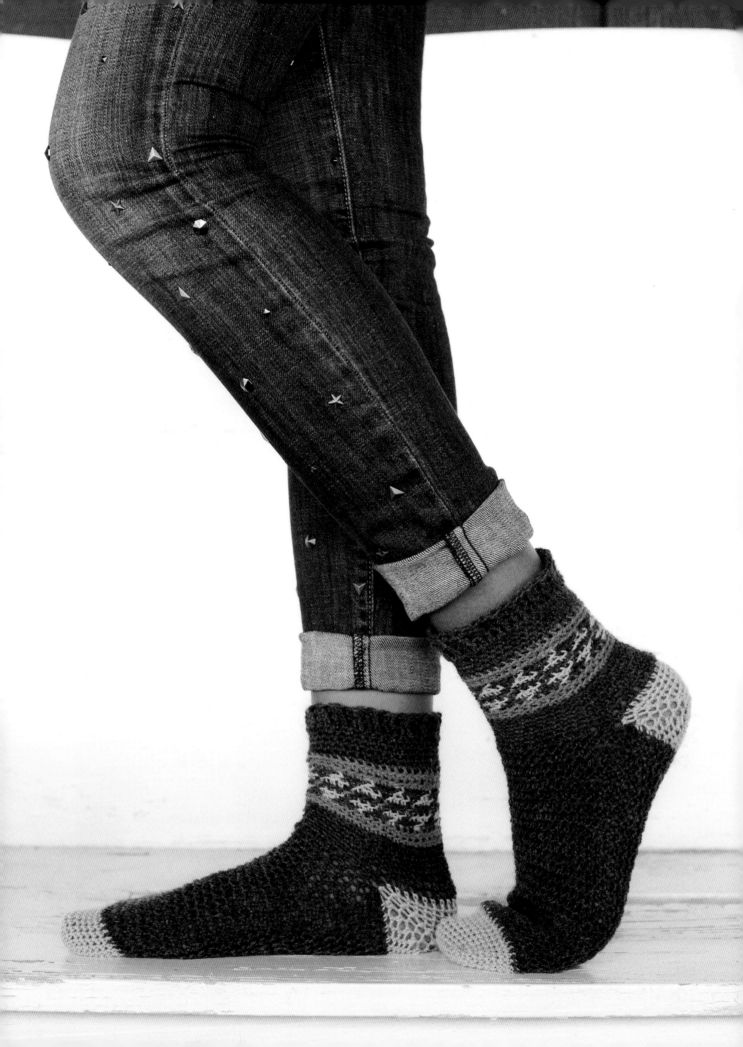

CROSS-COUNTRY SOCKS

>>>>>>>>>>>>>>>>>>>>

GO AHEAD, KICK OFF YOUR SHOES AND GET
COMFORTABLE WITH THESE COZY HANDMADE SOCKS.
YOU'LL LOVE SHOWING OFF THE CONTRASTING HEELS AND
TOES AND THE STRIKING ANKLE DETAIL.

FINISHED SIZE

Sock measures 6½ (7¼, 8, 8¾)"
(16.5 [18.5, 20.5, 22] cm) foot
circumference and 4½" (11.5 cm)
leg length from top of heel. Foot
length is adjustable.

YARN

Worsted weight (#4 Medium).
Shown here: Berroco Ultra Alpaca
Fine (50% Peruvian wool, 30%
nylon, 20% superfine alpaca;
433 yd [400 m]/3½ oz
[100 g]): #12189 Barley (A),
#12186 Caribbean Mix (B),
#1292 Tiger's Eye Mix (C), 1 skein each; or

#1207 Salt & Pepper (A),
#12114 Tea Rose (B), #1294
Turquoise Mix (C), 1 skein each.

HOOK

Size U.S. E/4 (3.5 mm); U.S.
F/5 (3.75 mm).

*Adjust hook size if necessary
to obtain correct gauge.*

NOTIONS

Stitch markers; tapestry needle.

GAUGE

10 hdc and 8 rows = 2" (5 cm)
with smaller hook.

NOTES

◆ The socks are worked in
continuous rounds. Use stitch
markers to mark the end of each
round.

◆ Only the charted section is
worked in sc through the back loop
only.

◆ You will carry a second strand of
yarn on all charted rounds.

INSTRUCTIONS

Toe

With B and smaller hook, ch 9 (11, 13, 15).

Rnd 1: Sc in 2nd ch from hook and in each ch across, rotate piece to work along opposite edge of the foundation ch, sc in each ch across—16 (20, 24, 28) sc.

Rnd 2: 2 sc in 1st st, sc in next 6 (8, 10, 12) sts, 2 sc in next 2 sts, sc in next 6 (8, 10, 12) sts, 2 sc in last st—20 (24, 28, 32) sc.

Rnd 3: Sc in each st around.

Rnd 4: 2 sc in 1st st, sc in next 8 (10, 12, 14) sts, 2 sc in next 2 sts, sc in next 8 (10, 12, 14) sts, 2 sc in last st—24 (28, 32, 36) sc.

Rnd 5: Sc in each st around.

Rnd 6: 2 sc in 1st st, sc in next 10 (12, 14, 16) sts, 2 sc in next 2 sts, sc in next 10 (12, 14, 16) sts, 2 sc in last st—28 (32, 36, 40) sc.

Rnd 7: Sc in each st around.

Rnd 8: 2 sc in 1st st, sc in next 12 (14, 16, 18) sts, 2 sc in next 2 sts, sc in next 12 (14, 16, 18) sts—32 (36, 40, 44) sc.

Rnd 9: Sc in each st around.

Foot

With A, hdc in each st around until Foot reaches below the ankle bone.

Heel Opening

With larger hook, fsc 16 (18, 20, 22), change back to smaller hook, skip next 16 (18, 20, 22) sts, place a st marker after 8th (9, 10, 11) fsc, sc around to st marker for new beg of rnd (center back)—32 (36, 40, 44) sc.

Leg

Rnds 1–6: Sc in each st around.

Rnds 7–8: With C, sc blo in each st around.

(continued on page 114)

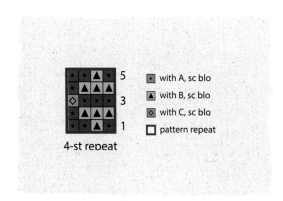

5

3

1

4-st repeat

- ⊡ with A, sc blo
- ▲ with B, sc blo
- ◈ with C, sc blo
- ☐ pattern repeat

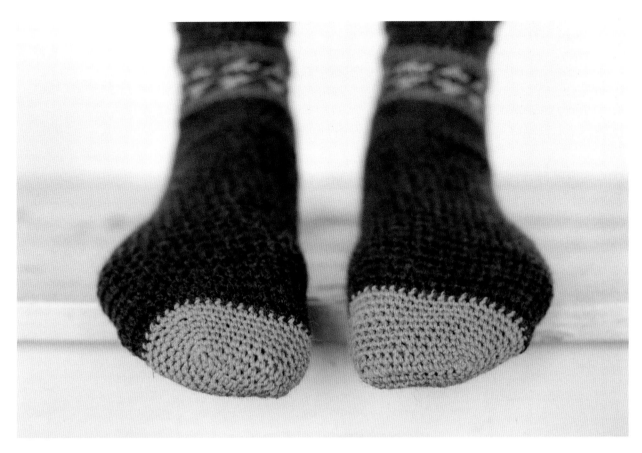

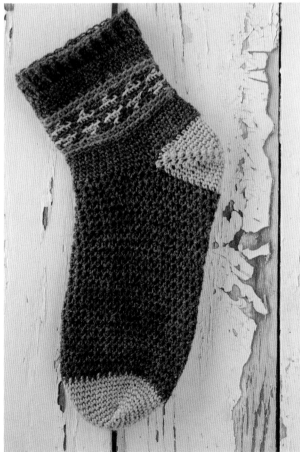

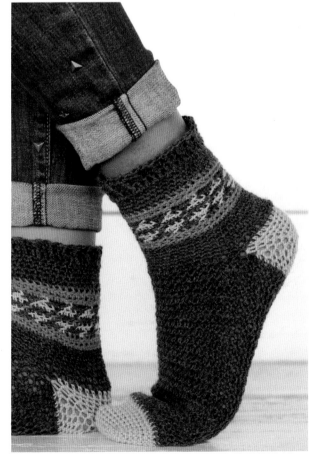

Rnds 9–13: Work Rows 1–5 of chart, working 4-st pattern rep 8 (9, 10, 11) times around.

Rnds 14–15: With C, sc blo in each st around.

Rnd 16: With A, sc blo in each st around.

Rnds 17–19: Sc in each st around.

Cuff

Rnd 1: Ch 3 (counts as dc throughout), dc in each st around, sl st in top of beg ch-3 to join.

Rnds 2–3: Ch 3, [FPdc around next st, dc in next st] around to last st, FPdc around last st, sl st in top of beg ch-3 to join; fasten off.

Heel

With RS facing, hold Sock with Cuff down.

Rnd 1: Join B with sl st in right corner of the Heel opening, 2 sc in the corner, place marker between the last 2 sc, sc in next 16 (18, 20, 22) sts, 2 sc in left corner, place marker between last 2 sc, sc in next 16 (18, 20, 22) sts, sc in next sc before 1st marker for new beg of rnd—36 (40, 44, 48) sc.

Rnd 2: *Sc2tog, sc in each st to last 2 sts before next marker, sc2tog, sc in marked st; rep from * once—4 sts dec'd.

Rep last rnd 5 (6, 7, 8) more times—12 sts rem. Fasten off. Using a yarn needle, sew Heel closed.

Repeat instructions to make second sock.

Finishing

Weave in ends.

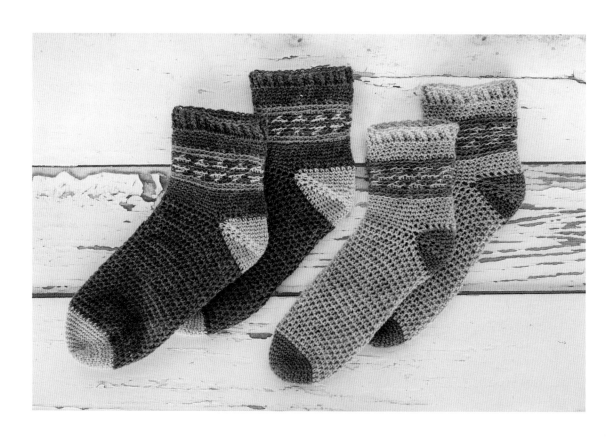

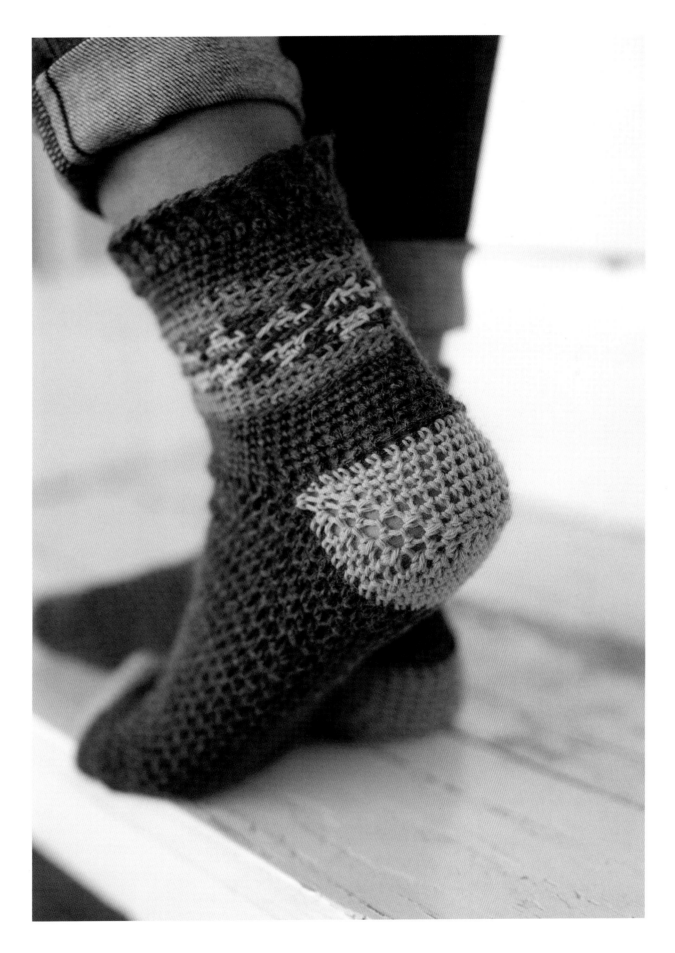

PLAN ACCORDINGLY

STITCH GLOSSARY

>>>>>>>>>>>>>>>>>>>>

ABBREVIATIONS

beg
beginning; begin; begins

blo
back loop only

BPdc
back post double crochet

CC
contrasting color

ch
chain

dc
double crochet

dec'd
decreased

FPdc
front post double crochet

fsc
foundation single crochet

hdc
half double crochet

MC
main color

rem
remaining; remain; remain(s)

rep
repeat; repeating

rev sc
reverse single crochet

rnd(s)
round(s)

RS
right side

sc
single crochet

sc2tog
single crochet two stitches together

sl st
slip stitch

st(s)
stitch(es)

WS
wrong side

<<<<<<<<<<<<<<<<<<<<<<<<<<<<<<<<<<<<<<<<<<<<<<<<<<<<

Adjustable ring

Make a large loop with the yarn, holding the loop with your fingers **(Figure 1)**. Insert the hook into the loop. Yarn over the hoop and pull through the loop on the hook **(Figure 2)**. Continue to work indicated number of stitches into the loop. Pull on yarn tail to close loop.

Chain (ch)

Make a slipknot and place it on crochet hook. *Yarn over hook and draw through loop on hook. Repeat from * for the desired number of stitches.

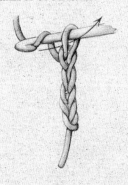

Slip Stitch (sl st)

*Insert hook into stitch, yarn over hook and draw loop through stitch and loop on hook. Repeat from *.

Half Double Crochet (hdc)

*Yarn over, insert hook in stitch **(Figure 1)**, yarn over and pull up loop (3 loops on hook), yarn over **(Figure 2)** and draw through all loops on hook **(Figure 3)**; repeat from *.

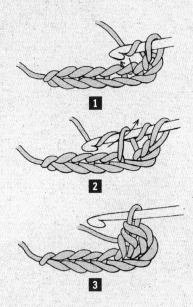

Back Post Double Crochet (BPdc)

Yarn over hook, insert hook from back to front to back again around the post of the stitch indicated, yarn over and pull up a loop (3 loops on hook), [yarn over hook and draw through 2 loops on hook] 2 times—BPdc made.

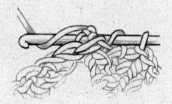

Front Post Double Crochet (FPdc)

Yarn over hook, insert hook from front to back to front again around the post of the stitch indicated, yarn over and pull up a loop (3 loops on hook), [yarn over hook and draw through 2 loops on hook] 2 times—FPdc made.

<<<<<<<<<<<<<<<<<<<<<<<<<<<<<<<<<<<<<<<<<<<<<<<<<<<<<<<<<<<<

Single Crochet Two Together (sc2tog)

Insert hook in stitch, yarn over, and draw up a loop. Insert hook in next stitch and draw up a loop. Yarn over hook **(Figure 1)**. Draw through all 3 loops on hook **(Figures 2)**—1 stitch decreased.

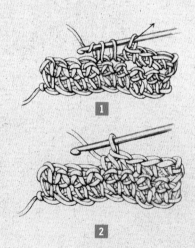

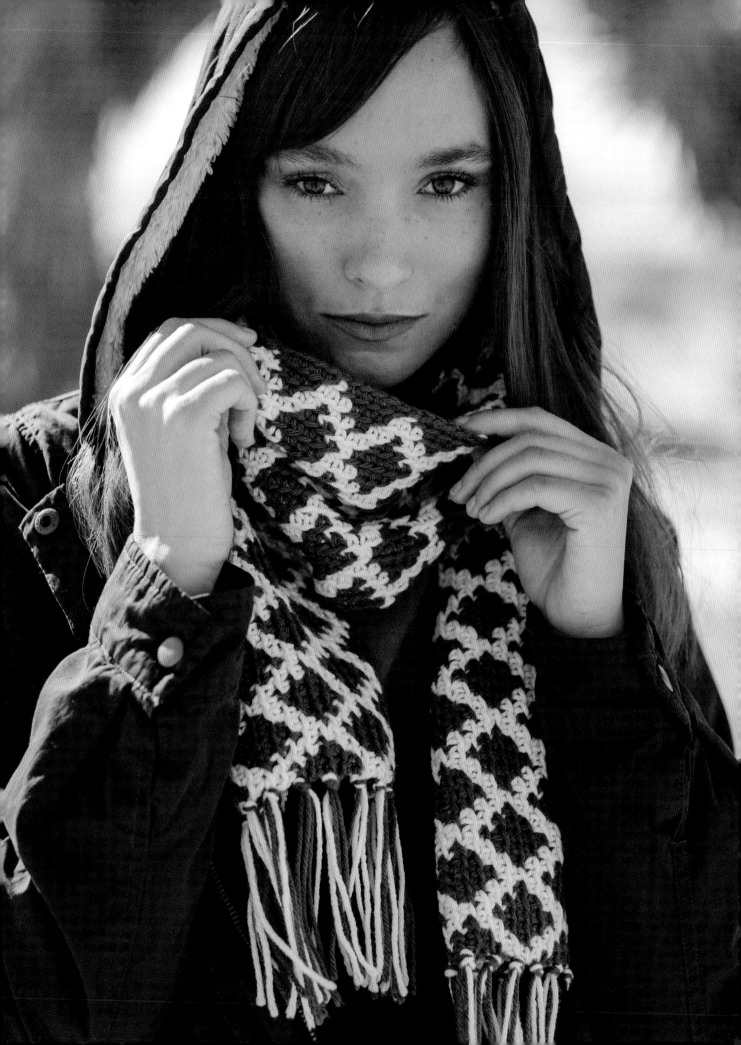

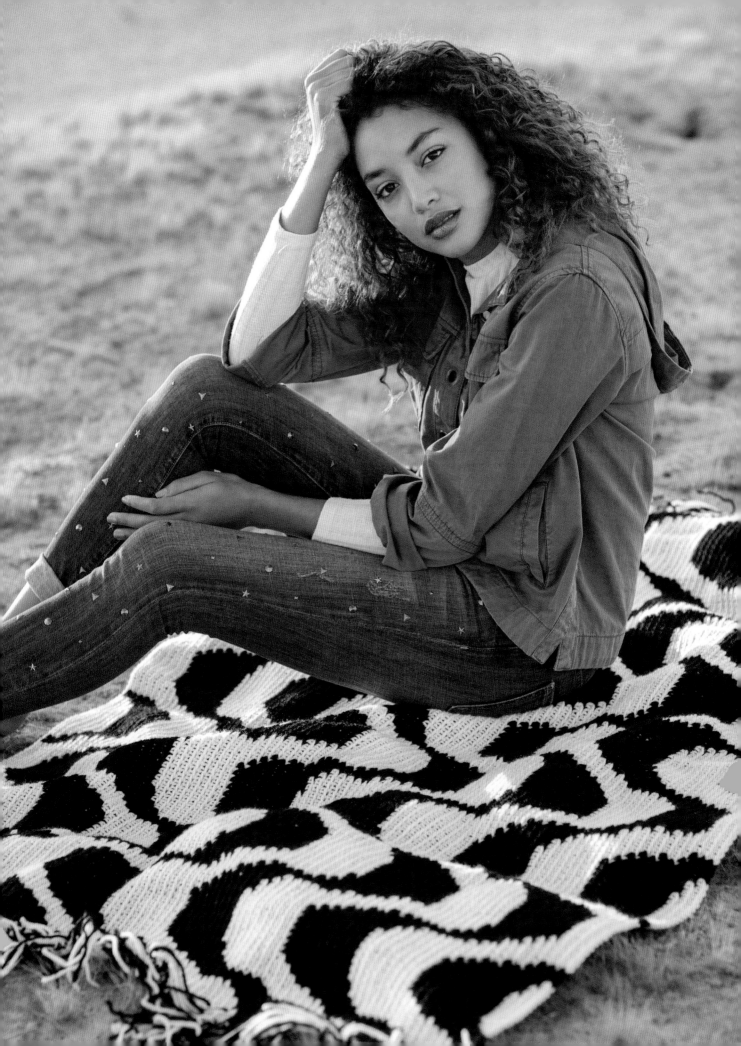

RESOURCES FOR YARN

Berroco

1 Tupperware Drive
Suite 4, N. Smithfield, RI
02896-6815
(401) 769-1212
berroco.com

Big Twist Yarns

Jo-Ann Fabric
& Craft Stores
5555 Darrow Road
Hudson, Ohio 44236
(888) 739-4120
joann.com

Cascade

cascadeyarns.com

Knit Picks

13118 NE 4th Street
Vancouver, WA 98684
(800) 574-1323
knitpicks.com

Lion Brand

135 Kero Road
Carlstadt, NJ 07072
(800) 258-YARN
lionbrand.com

Malabrigo

(786) 427-1048
malabrigoyarn.com

Quince & Co

quinceandco.com

<<<<<<<<<<<<<<<<<<<<<<<<<<<<<<<<<<<<<<<<

Metric Conversion Chart

To Convert	To	Multiply By
Inches	Centimeters	2.54
Centimeters	Inches	0.4
Feet	Centimeters	30.5
Centimeters	Feet	0.03
Yards	Meters	0.9
Meters	Yards	1.1

ABOUT THE AUTHOR

>>>>>>>>>>>>>>>>

Alessandra Hayden learned to crochet as a child growing up in Sao Paulo, Brazil, starting with a tiny hook and some slippery silk thread. After crocheting on and off for many years, her love of the craft was reinvigorated in her early twenties and soon after became her career. She completed the Master Program of Crochet Techniques through the Crochet Guild of America, sells crocheted pieces online, and has published patterns in *Inside Crochet* and *Crochet World Magazine*. Visit Alessandra online at justbehappycrochet.com.

DEDICATION

I dedicate this book to my husband, Rob. Thank you for your patience and constant support that enabled me to work on this huge, time-consuming project. Also, thank you to my kids, Lucas and Sophia—you guys are the most wonderful things I have ever created. You are my daily inspiration and the daily motivation I need to keep going.

>>>>>>>>>>>>>>>>>>

ACKNOWLEDGMENTS

There are so many people who helped me on the journey of writing this book. Thank you to all my awesome testers: Courtney Knorr-Warriner, Sarah Craven, Robyn Katofsky Axelrod, Leslie Hill, Cass Dodge, Jennifer Neerhof, Cassie Murphy. Thank you to the F&W team (Stephanie White and Maya Elson) and Harper Point Photography for making my words spark. And a big thanks to my family and friends for their encouragement and support.

INDEX

>>>>>>>>>>>>>>>>>>